NORMA FLECK

2005 Graydon, Shari

In Your Face : The Culture of Beauty and You

IN YOUR FACE

THE CULTURE OF BEAUTY AND YOU

SHARI GRAYDON

ANNICK PRESS

TORONTO + NEW YORK + VANCOUVER

Annick Press Ltd.
All rights reserved. No part of this work covered by the copyrights hereon may be reproduced or used in any form or by any means—graphic, electronic, or mechanical—without the prior written permission of the publisher.

We acknowledge the support of the Canada Council for the Arts, the Ontario Arts Council, and the Government of Canada through the Book Publishing Industry Development Program (BPIDP) for our publishing activities.

Edited by Pam Robertson
Copy edited by Elizabeth McLean
Graphic strips by Krista Johnson
Cover model: Lisa Cheung
Cover photo by Kent Kallberg Studios Ltd.
Cover design and interior design by Irvin Cheung/iCheung Design

The text was typeset in Apollo, Golden Gate Gothic, Matinee Gothic, Motel Gothic, and Univers

Cataloging in Publication
Graydon, Shari, 1958–
 In your face : the culture of beauty and you / written by Shari Graydon.

Includes bibliographical references and index.

ISBN 1-55037-857-0 (bound).—ISBN 1-55037-856-2 (pbk.)

 1. Beauty culture. 2. Beauty, Personal—Psychological aspects.
I. Title.

TT957.G73 2004 391.6'3 C2004-902341-1

Printed and bound in Canada

Published in the U.S.A. by	**Distributed in Canada by:**	**Distributed in the U.S.A. by:**
Annick Press (U.S.) Ltd.	Firefly Books Ltd.	Firefly Books (U.S.) Inc.
	66 Leek Crescent	P.O. Box 1338
	Richmond Hill, ON	Ellicott Station
	L4B 1H1	Buffalo, NY 14205

Visit our website at: **www.annickpress.com**

contents

INTRODUCTION

BEAUTY *rules.*

And not just in our fantasies. Do you ever get the impression that the girls and guys blessed with knock-'em-dead good looks are much more likely than everyone else to fall into fame and fortune?

Turn on your favorite TV show, scan a few magazine covers at the local corner store, or check out the singers who make it big: chances are the faces and bodies you're looking at are more attractive than most of the people you see walking down the street or hanging out in the hallways at school.

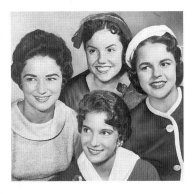

Although the Miss America contest began in the 1920s, beauty pageants started getting a lot more attention in the 1950s with the invention of television. These 1959 "queens" hold the titles Miss Iowa, Miss Mississippi, Miss Kansas, and Miss Arkansas.

Every day, in a thousand ways, we're reminded of how much easier the world seems to be for people blessed with the right hair, face, and body parts. You can't help but wonder whether your own life would be just that much better if the reflection looking back at you from the mirror every morning were a bit more like Brad Pitt or Jennifer Lopez, and a bit less like your Uncle Howard or Aunt Lou.

And yet, ideas about what's "beautiful" change all the time. Your closet probably has evidence of the fact that fashion is awfully fickle: what's considered cool and desirable one month can be "so over" the next. And not everyone has the same tastes: not here in North America, and certainly not in other parts of the world. Open up any history book or foreign magazine: you'll see people whose looks may be admired in their own countries, or would have wowed their friends in the past, but wouldn't turn heads in *your* crowd.

Ever ask yourself why? Why then, and not now? Why there, and not here? Why that look, and not this?

Even though the standards of beauty—not to mention the methods for achieving it—have changed radically over time and across cultures, it's pretty clear that the desire to look hot is hard-wired into human nature. Art in the tomb of an Egyptian noble-man who lived around 2400 BC shows a slave beautifying his feet; a couple of thousand years later, Cleopatra, an acknowledged babe of her day, was big into eyeliner; and aspiring hotties of the 21st century can choose from a seemingly endless array of beauty aids.

In Your Face sets out to discover:

* why we're so fascinated by beauty;
* what we've done over the centuries and across cultures to stand out, fit in, and measure up;
* who gets to decide what's hot and what's not; and
* what forces and sources shape our views.

We'll examine the beauty lessons we learn in everything from bedtime stories to blockbuster movies and check out the vast and varied definitions of beauty from all over the world. And our exploration of the enduring appeal of the young and the healthy will help to explain some of the wild and wacky things people have done in the past—and are doing today—in pursuit of looking good.

We'll compare the gap in the

Cleopatra, an Egyptian queen, reportedly used her beauty and charm to seduce the most powerful Roman leaders of her time.

beauty standards applied to guys and girls, and shine some light on the power games that have been played in the name of beauty to keep some people in their place. Along the way, we'll look at the advantages and the disadvantages (yes, there are some!) of being judged a hot property.

In Your Face goes backstage at beauty contests—both the kind that focus on tiaras and prize money, and the kind that happen every day in school hallways and bathroom mirrors. We'll also open the vault on the folks who get rich by making the rest of us feel insecure, and expose the gap between what we see and what's actually achievable. And we'll check out the impact that being beautiful had on the lives of a couple of great-looking teens.

Understanding the powers and pitfalls of trying to look our best won't necessarily inspire us to toss out the tweezers or hair gel. But putting beauty into perspective can definitely help us to stop feeling so controlled by it. The treatment—if not the cure—includes valuable reality checks and alternative beauty tips; great strategies for wrestling your feelings about image pressure to the ground.

ONCE UPON A TIME

What was it for you? Your mother's face? A favorite stuffed animal? That magnificent superhero costume you wore on your fourth Halloween? Or do you even remember the first time you noticed that something or someone was "beautiful"?

Probably not. From the moment we're born, we hear many things described as being beautiful, from the wrinkly red faces of babies to Tiger Woods' golf swing. Beauty becomes something we learn about without even trying.

A woman fishing off the end of a dock hauls in her best catch of the day and proclaims with great satisfaction, "Yep, it's a beaut!" A man standing in front of a remarkable painting says, "How beautiful!" A child presented with a shiny new bike, fresh from the store window, exclaims, "Wow, it's beautiful!"

And—depending on who's looking, listening, or eating—a pink sunset, a brilliant hockey goal, a great piece of music, or a homemade cake could each be considered "beautiful."

Once we're toddlers, old enough to follow a fairy tale, we *really* begin to learn about beauty—especially as it relates to people.

FINDING THE "FAIR" IN FAIRY TALES

FROM HANS CHRISTIAN ANDERSEN to the Brothers Grimm to Walt Disney, the stories we hear as kids are full of characters who are incredibly good-looking (or incredibly not): Sleeping Beauty, Beauty and the Beast, The Ugly Duckling... Fairy tale lessons are very familiar to us before we even enter kindergarten.

Let's start with Snow White and the Seven Dwarves, a story that's driven by one woman's obsession with being "the fairest of them all." When Snow White's beautiful stepmother gazes into her mirror and asks it to tell her the truth, she becomes enraged with the answer that Snow White is the prettiest. In order to regain her status as the fairest, the stepmother goes to great lengths to try to kill her stepdaughter. She hires a hunter, disguises herself as an old woman, and poisons an apple and a comb. Then, when she finally appears to have succeeded, and Snow White is lying in a glass coffin, along comes the king's son. He's so struck by her beauty that he can't bear to live without her. Fortunately, this being a fairy tale, his kiss revives her, and she immediately falls in love and marries him.

So what does Snow White teach us about beauty?

Lesson #1. Women are jealous of each other's good looks, and older women especially resent the beauty of younger women.

Lesson #2. Being young and beautiful is dangerous: you can't trust even the people closest to you. In fact, in the original version of the story, it was Snow White's *mother,* not her stepmother, who turned on her.

Lesson #3. The only condition necessary for a prince to fall in love with a maiden is that she is beautiful. (Who cares whether she's fun to hang out with, has a sense of humor, shares any of his interests, or is even conscious!)

Lesson #4. If you're female, beauty is the ticket to being rescued by a good-looking guy and living "happily ever after."

Right now, you can probably think of a few other fairy tales that deliver some of the same messages: Sleeping Beauty, for instance, or Cinderella. In both cases, handsome—and, it goes without saying, rich—princes go ga-ga over the girls in question almost solely on the basis of their looks.

Aurora (Sleeping Beauty) is comatose when her prince hacks through the weeds to find her passed out in the castle, but he falls in love at first sight. And Cinderella bowls her prince over the minute she enters the ball in all her fairy godmother–supplied finery. Even though she is also incredibly selfless and warm-hearted, the prince would probably never even have looked at her, let alone asked her to dance, if she hadn't been wearing the right clothes. And it's not until after he falls in love with her dressed up like a princess that he discovers her true circumstances and generous nature. Ditto with Sleeping Beauty: she's kind and sweet, but

This 1888 depiction of Cinderella—whose story goes back many centuries—doesn't look much like the Disney image familiar to most of us.

it's not as if those qualities are evident while she's passed out!

Meanwhile, Cinderella's ugly stepsisters are almost as jealous

and mean-spirited as Snow White's stepmother. Maleficent, the vindictive fairy who puts the sleeping curse on Aurora, is described as being hideous-looking. (In Disney's film version of the tale, she has a sharp, pointed face, sneering lips, and no hair.)

So on the basis of these stories, we also learn:

Lesson #5: Beauties are warm-hearted, forgiving, and good.

Lesson #6: Women who *aren't* beautiful are mean and spiteful.

Although most fairy tales bear little resemblance to reality (pumpkins don't usually become carriages, for one thing), we still absorb the lessons—no studying necessary.

The characters' emotions are familiar, too. Even if you've never made your better-looking friend or skinnier sister wear rags, scrub floors, or eat poison, feeling envious of another person's beauty is not uncommon.

But it's what you do with the envy that makes the difference. Part of the Cinderella story's message is that vindictiveness and spite rank fairly high on the "guaranteed to make you ugly" scale. But imagine if the stepmother and sisters had just *fantasized* about Cinderella scrubbing the floor, and then gotten a life...

Beauty and the Beast is another classic tale that reinforces the idea that beauty = good, while ugly = evil. In the original fairy tale, Beauty (or Belle, as she's called in the Disney movie) has two sisters who are lazy, greedy, and vain—not to mention jealous of their better-looking younger sister. And surprise, surprise, the heroine herself is charming, kind, hardworking, and generous.

Yet this is one fairy tale that goes a step further. Other elements of the story provide a completely different take on beauty: specifically, the dangers of judging a book by its cover. The Beast—with his hairy, brutish exterior—isn't at all beautiful in the conventional sense. But despite his looks, he's as kind and generous as Beauty herself. Of course, underneath he's a handsome prince, but it's only by loving him in his ugly form that Beauty is able to unlock the spell he's imprisoned by.

The messages of Beauty and the Beast are a little more encouraging for those of us who don't happen to stop traffic every time we walk down the street:

Lesson #7: Beauty is only skin-deep: a person's character, or inner beauty, is much more important than superficial exteriors; and

Lesson #8: Those who recognize and choose inner goodness over beautiful exteriors will be rewarded.

In other words, character and personality are underrated but essential features.

BEAUTY AT THE BOX OFFICE

YOU COULD CONSIDER FAIRY TALES the kindergarten equivalent of beauty school. They teach you the basics. But then you "graduate" to teen and adult movies, which provide a new level of information (some would say *mis*information) about the powers and pitfalls of beauty.

Movies for older audiences may feature less animation, different locations, and more grown-up challenges, but after a while you might start to notice that the character types and basic story lines are very familiar. Fairy tale lessons resurface time and again.

Consider the movies you've seen or even just heard about. Chances are you can probably add your own examples to the following categories:

Prince Rescues Beautiful Girl: You'd think that Snow White, Sleeping Beauty, and Cinderella might have exhausted our appetite for this story line by the time we hit school, but apparently not. Moviemakers are obviously counting on the appeal of a fantasy in which all we have to do is be discovered by our dream date. Julia Roberts' first big movie, *Pretty Woman,* was a reworking of this tale, as is the more recent flick *Maid in Manhattan.*

Plain Jane Gets Transformed: At essence, this story suggests that we're all capable of being beautiful if we just work at it. If we buy the right clothes, apply the right makeup, and learn how to walk right, be cool, or fit in, we too can become a beauty queen or catch a good-looking guy. The musicals *Grease* and *My Fair Lady* are classic tellings of this story, and more recent movies that fit into the mold include *Miss Congeniality, The Princess Diaries, Never Been Kissed,* and *My Big Fat Greek Wedding.*

THINGS COULD BE WORSE

So you're in the change room at your favorite clothing store, trying on some jeans. But here's the thing: if the waist fits, the butt's too baggy, and if the pants hug your tush, the waist is too big.

It happens, sure, but it could be worse. At least you're not built like a Disney heroine or video game babe!

Take Jasmine from the movie *Aladdin*, or Lara Croft from *Tomb Raider*. If they were suddenly transformed into real women, with the same bodily proportions, they'd have enormous difficulty buying clothes from just about any shop you can think of. Their figures are so exaggerated that they would probably need a size 2 to fit their waists, and a size 8 or 10 to accommodate everything else!

Even Angelina Jolie, who has a classic hourglass figure and plays Lara Croft in the films, doesn't have the extreme dimensions of her video counterpart.

Beauty Is Only Skin Deep: The wisdom Belle shows in embracing the Beast, despite his hideous appearance, is echoed in more recent stories. In the film *Shrek,* the title character is an ugly green ogre who falls in love with the beautiful Princess Fiona. Feeling hopeless about his chances of winning her, he laments that "people judge me before they know me." But it turns out Fiona is an ogre too, who takes on the guise of princess during the day and reverts back to monster mode every sundown. In the end, Shrek's love for her—like hers for him—is more than skin deep.

Versions of this story, such as *The Truth about Cats and Dogs,* tend to feature generous-minded—or, in the case of *Shallow Hal,* temporarily blinded—guys who discount the less attractive exteriors of female characters

and fall in love with them for their shining personalities. And *Ten Things I Hate about You* explores the other side of the coin, making it clear that a surly personality can seriously undermine good looks.

But the fairy tale conventions that equate beauty with goodness and ugliness with evil also show up in many contemporary stories. In both animated and live-action movies, one thing you can generally count on is that the heroes and heroines will be better-looking than average. Occasionally, evil characters are played by very attractive actors—the female villains in James Bond movies are always beautiful—but more often than not, the good guys—male and female—are gorgeous, and the bad ones are not.

REALITY CHECK

MOVIEMAKERS RELY SO MUCH ON THE CLASSIC FAIRY TALES we're told as kids, it sometimes seems like original ideas—or new messages about beauty—are in short supply. But what if we changed the fairy tales themselves? Some writers are doing just that—turning traditional stories upside down and offering new takes on some old themes.

Consider Robert Munsch's story, *The Paper Bag Princess*. In it, the princess, Elizabeth, outsmarts the dragon who has destroyed her castle and clothes. But when she arrives at the dragon's cave to rescue her abducted prince (and intended future husband), Ronald is so ungrateful that he takes one look at her messy hair and paper bag dress and tells her she stinks. Elizabeth replies, "Ronald, your clothes are really pretty and your hair is very neat. You look like a real prince, but you are a bum." And she decides not to marry him after all.

A big part of what makes the story funny is that it messes with what readers expect. Unlike many fairy tales, Elizabeth is not your typical damsel-in-distress, passively waiting to be rescued. Smart and fearless, she slays the dragon herself. Then she gives

Ronald the boot because he's so petty that he can't see past her clothes to appreciate her courage and intelligence. When you get to the last scene of the story, you can't help but think, "You go, girl!" when Elizabeth delivers her withering comeback.

No doubt about it, Cinderella and Snow White have some romantic appeal. But when you live in the real world without fairy godmothers and miracle-inducing kisses, a little kick-butt attitude goes a long way.

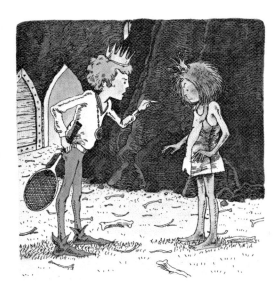

Elizabeth, the Paper Bag Princess, turned the typical fairy tale scenario on its head by rejecting her suitor for being so preoccupied by superficial appearances that he failed to appreciate her bravery and wit.

And when a writer or movie director delivers it, yanking a predictable story out of shape, the element of surprise can work very well. And it's starting to happen more and more often.

CHICKS IN CHARGE

IN EVERYTHING FROM MOVIES and fashion magazines to reality TV shows and even commercials, many stories focus on whether or not a woman's appearance is up to scratch. Female characters tend to suffer much more beauty pressure than males. As a result, we need a whole new category to describe the rare stories that feature a heroine like Elizabeth who challenges the idea that her beauty is all that's important about her.

Like *The Paper Bag Princess*, the Drew Barrymore movie *Ever After* puts a new twist on a familiar story. In this update of Cinderella, Drew's character Danielle is forced to dress in rags and work all day, while her stepsisters are spoiled by her hateful stepmother. Unlike Cinderella, however, Danielle takes charge of her

own fate, rescuing a beloved servant, saving the prince's life, and challenging the king when she thinks he's wrong. Of course, she's also very pretty, but in *Ever After,* her success is due more to her courage, intelligence, and initiative.

BEAUTY MYTHS, GREEK STYLE

IF SOMEONE TOLD YOU that you had the kind of face that would "launch a thousand ships," would you consider it a compliment, or cross the person's name off your list of friends?

Probably it would depend on how much you knew about Helen of Troy.

Too-Hot Helen

In Greek legend, Helen was the daughter of Leda, the queen of Sparta, and Zeus, the father of the gods. Even as a child, she was renowned for her beauty, and by the time she was a teenager practically every guy in the country had a crush on her. Recognizing how desirable she was and worried about her long-term safety, Helen's mortal father made a deal with all of her suitors. Each would swear an oath that no matter who was selected to be her husband, all of the others would help the successful suitor, should anything bad happen in the future.

Eventually, Helen's father married her off to Menelaus. But a number of years into the marriage, an incredibly handsome mortal named Paris seduced Helen away from her husband with the aid of Aphrodite, the goddess of love

In both Greek and Roman myth, Helen is the epitome of beauty in the human world, just as Aphrodite (or Venus, in Roman myth) is in the realm of the gods. The ancient Greek statue known as the *Venus de Milo* has long been seen as embodying quintessential female beauty.

and beauty. When Menelaus discovered that Paris had spirited Helen to Troy, he reminded Helen's former suitors of their oaths, and they began preparing for war in an effort to get her back.

This is where the "thousand ships" come in: it was her legendary beauty that inspired the men to set sail for Troy, willing to risk their lives to bring her home.

Helen's story has long been held up as a prime example of beauty's power and the lengths people will go to as a result of its hold over them. It also helps to explain why myth-inspired stories keep showing up—in everything from fairy tales for five-year-olds to action movies for adults. For example, Hercules has inspired a couple of TV series over the years, and movies like *Troy* and *O Brother Where Art Thou* also draw on Greek stories handed down over the centuries. Even though myths feature gods and goddesses who boast supernatural powers, they tell universal truths about human behavior. We're drawn to these stories because most of us can relate to the emotions felt by their characters.

You may never raise your fists in a fight over another person, but you can probably recall having developed a childhood crush on a favorite teacher, or becoming infatuated with someone in your English class. And chances are it may even have driven you to do something crazy. Ever carved someone else's initials on your desk, or called their number just to hear them say hello?

Mighty Aphrodite Meets Adorable Adonis

Despite being the goddess of beauty and love, Aphrodite herself suffered such longings. Although she had the power to cause others to fall in love and become infatuated, she, too, experienced the pain of becoming overly attached to someone's beauty.

Adonis was the source of her woes. In Greek mythology, he grew up to be the handsomest of men. Aphrodite was so obsessed by how gorgeous he was that she took up hunting just so she could be around him 24/7.

Unfortunately, Adonis's good looks brought about his early death. When he was out hunting one day, another god, jealous of his looks, sent a wild boar to attack him. The boar gored Adonis in the leg and Aphrodite, though she wept and pleaded with the Fates, was unable to prevent him from dying.

Is it reassuring to learn that even the so-called gods weren't immune to jealousy or heartbreak? Feeling envious of someone else's good looks is a normal—if uncomfortable—experience, as is the pain of falling in love with someone who isn't nearly as infatuated with you as you are with them.

Adonis's good looks attracted the adoration of Aphrodite, the goddess of love and beauty, but neither his looks nor the goddess's love could save him from a wild boar attack.

Revenge on Narcissus

Like Adonis, Narcissus was born beautiful. But at his birth, a soothsayer (think fortune-teller without the crystal ball or tarot cards) predicted that he would live a long life only if he never came to know himself. At first, nobody really understood what that meant.

By the time he was a teenager, Narcissus had all sorts of nymphs drooling over his good looks. But he paid no attention to them, breaking hearts with little concern for the emotional wreckage he was leaving behind. In response, one of the girls he had cruelly rejected prayed to the gods that Narcissus himself would fall in love and be treated as badly as he had treated others.

Hmm—does this sound like anyone you know? The pain of rejection—and the momentary vindictiveness it can inspire—is certainly familiar to most of us. And you can probably even picture the teen flick that could be made from this scenario.

But wait: the Narcissus myth has an unusual twist. One day, thirsty from hunting, Narcissus knelt down by a pool of water to take a drink. When he caught sight of his reflection in the still pond, he fell head over heels in love—with himself! The harder he tried to embrace the person he saw in the pool, the more frustrated he became, because all he ever did was make waves that wrecked his image. Eventually he died of a broken heart.

Many interpret Narcissus's story as a warning about the dangers of cold-heartedness and excessive vanity. Today we use the word "narcissist" to describe a person who is so filled with self-admiration that he or she is unable to feel anything for anyone else.

IMAGE REFLECTIONS

THE REASON YOUR SCHOOL doesn't offer Beauty 8 or Good Looks 10 is because you've been learning the relevant lessons—whether they're true or not!—forever.

What's more important, though, is to know where the messages are coming from and what they mean. From picture books to movies, from myths to video games, the stories passed down from one generation to another and retold in ever evolving ways shape our views about beauty—what it is and how it affects people. What have we seen so far?

* Even if you're not an ogre or a beast, inner beauty—warmth, intelligence, generosity, a sense of humor—are handy things to have; they help you attract friends and get what you want in the world.

* It's normal to experience envy; almost everyone feels it at one time or another. Vindictiveness, however, as demonstrated by the evil characters in fairy tales, is a turn-off.
* If you're female it's best not to count on being rescued by a prince because: a) he might not show up, and b) who's to say you'll want to hang out with him, or go where he wants to take you, when he does?
* Having enough smarts to slay the dragon yourself lets you make your own choices, as opposed to sitting around and hoping to "be chosen."
* Self-confidence (Belle and Danielle) is good; self-infatuation (Sleeping Beauty's stepmother and Narcissus) is not.
* Finally, it's possible to boost somebody's inner glow just by loving them.

This last point is part of the message that comes through in Beauty and the Beast. It may sound hokey, but it's probably the most important lesson of all. And it relates a lot to the next chapter, in which we look at how beauty is as much about who's looking and what they see, as who's being looked at.

THE EYE OF THE BEHOLDER

A scene in the movie *The Gods Must Be Crazy* shows a small, wiry African bushman stumbling upon the sight of a beautiful blonde woman getting dressed in the shade of a tree. As the scene unfolds, you hear the inner thoughts of the bushman, who's looking at the woman with a mixture of pity and amusement.

Even though she has Hollywood-style good looks, he thinks she's just about the ugliest creature he's ever seen. She's way too pale—like something that crawled out from under a rock—with stringy, "gruesome" washed-out hair that makes her appear very old. And she's much too large—he imagines he'd have to search the entire day to find enough food to feed her. Finally, as he watches her put on a blouse made from sheer fabric, he can't understand why she's covering her arms with what looks to him like hideous cobwebs.

Because the world of the African bushman is so unlike that of the woman, what he sees is completely different from what North American audiences see when viewing the same thing. The movie lets us understand his perspective and it challenges us to think differently about some things we normally take for granted—like what's beautiful.

Often we assume that our definitions of beauty are like everyone else's. Sure, we might disagree with friends about whether Justin Timberlake or Will Smith is the hottest; we might debate the relative charms of Selma Hayek or Britney Spears. But in general, we'd probably be able to come to some kind of consensus about the basics.

So it's odd to see a woman who would be judged very attractive by mainstream Western cultures being dismissed as ugly by someone from somewhere else. It helps to remind us that the images of beauty featured in North American movies, TV shows, and commercials represent only a few choices.

And it makes you wonder about how some physical characteristics—blonde hair, for instance, or height—came to be considered attractive. Who got to decide? What criteria were they using? And is it safe to assume that—the African bushman aside—everyone else agrees on the same basic standards?

The short answer to the last question is... absolutely not!

INDEFINITE DEFINITIONS

PEOPLE'S ATTEMPTS TO COME UP with a means of applying scientific principles to the measurement of beauty have just never panned out—but that hasn't stopped them from trying!

Take the ancient Greeks, for instance. Their theories about what was beautiful and what wasn't were very elaborate; they even went so far as to claim that beauty could be precisely measured and predicted, like geometry.

They settled on even features and identifiable ideals of symme-

try, shape, and proportion. They figured you could define the perfect human being as a mathematical formula, and this belief was reflected in the proportions of their statues and sculptures.

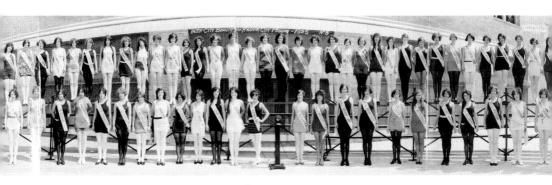

Attempts to come up with a "scientific" system of judging beauty contests like this one in Atlantic City in the 1920s failed. Measuring the distance between a woman's nose and chin, or the dimensions of her figure, just couldn't capture the essence of beauty.

Hundreds of years later during the Renaissance, the idea resurfaced. Artists of the time also proposed a measurable ideal. They argued that the perfect face could be divided equally into thirds: the distance from the hairline to the eyebrows should be the same as the distance from the eyebrows to the lower edge of the nostrils, and from the nostrils to the chin. The space between the eyes was supposed to be equal to the width of the nose. These ideals and systems influenced art for centuries.

But before you run for your ruler, consider this: although such calculations may produce beautifully balanced statues, they just don't cut it when applied to living and breathing human beings.

In the early days of the Atlantic City beauty pageant during the 1920s, one of the judges tried to come up with a measurement system that would help to determine the pageant winner in a "scientific" manner.

The judge who thought up the system had a great time measuring all the contestants, but the system itself was ultimately tossed out. As Norman Rockwell, a famous American painter and one of

the other judges, commented: "We found you can't judge a woman's beauty piecemeal; you have to take the whole woman at once."

More recently, researchers conducted an experiment involving the faces of 200 women, 50 of whom were professional models. Like Mr. Rockwell and his colleagues, they, too, found that there was no "formula" that could effectively measure who was hot and who wasn't.

What translates as attractive simply can't be determined by a mathematical equation. Tape measures gauge numbers, but beauty is clearly a bit more mysterious.

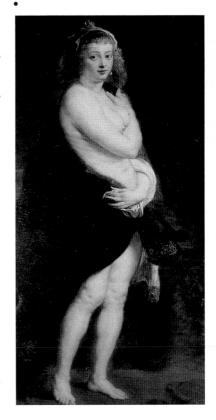

When celebrated Renaissance painter Peter Paul Rubens painted this portrait of his wife Helene, her cellulite-dimpled curves were considered womanly and beautiful.

From the Painters' Perspective

Classical art does a good job of reminding us how varied people's tastes are. Painters and other artists have depicted remarkably different ideals of human beauty.

Remember Aphrodite, the Greek goddess of beauty and love? In Roman myth she was known as Venus, and she's been vividly imagined by many artists through the ages. Each portrayed the woman who was said to embody "beauty" in a different way. The much admired *Venus de Milo,* a classic Greek statue from the second century BC, has voluptuous curves and not much of a waist. In *The Birth of Venus* by famous Renaissance painter Sandro Botticelli, the goddess has small breasts, a round tummy and blonde hair, but Romantic artist William Bougereau's version features a brunette. If the 16th-century Italian artist Titian's Venus were alive today, she'd probably wear a size 16. Flemish master Peter Paul Rubens painted her as noticeably plump by today's standards.

A successful 17th-century painter whose art hangs in galleries around the world, Rubens once said that "the body of a woman should be neither too thin and scrawny nor too large and fat." Yet he regularly painted nude female bodies—including that of his young wife, Helene—that today would only appear in the "before" portion of ads for a weight-loss program. The women Rubens celebrated in his art boast dimpled thighs, ample arms, and ripples of fat around their bellies. These days, people refer to particularly voluptuous women as being "Rubenesque."

Clearly, today's "plus size" dimensions were once cause for appreciation, not discrimination. What's considered "beautiful" and "ideal" depends—as the saying goes—on the eye of the beholder.

BAD HAIR DAYS THROUGH THE AGES

CHANGES IN FASHION DON'T ALWAYS TAKE CENTURIES.

Have you ever opened up one of your parents' high-school yearbooks and rolled your eyes at how incredibly geeky everybody—including your parents—looked in the 1970s or '80s? Even if the pictures are only head shots, the hairstyles alone are dead giveaways that the pictures were taken decades ago.

The history of hair fashion is a good way to put your own hair woes in perspective and see how beauty standards change over time. Through the centuries, women in particular have ironed and curled, dyed and teased, piled and pinned their hair into a wide variety of shapes and styles, trying desperately to ensure that the stuff growing out of their heads could be described as their "crowning glories."

Achieving "big hair" in the 17th century required a few things that would surely be out of place in your bathroom today. Wire was used as scaffolding to give a high hairdo its form, wool was stuffed inside the do to fill it out, and ornaments were attached to the final arrangement as decoration.

In the Victorian era, this meant piling their hair high to make their necks look longer. But in medieval times, when a high forehead was prized, women actually shaved the hair immediately above their faces, to lengthen their foreheads—like a sort of receding hairline that you'd have to keep reshaving every day or two to maintain the desired illusion!

At other times, "great hair" meant flat against the head and parted in the middle, or curls around the face, which were believed to signify a "sweet temper." In the 1920s, short and bobbed was a mark of modern sophistication, and in the 1950s, women's hair was teased and tortured into cotton candy–style "bouffants," some of which measured as wide as 14 inches across. Then long hair and afros became signs of rebellion in the 1960s, and hip young men traded in their crew cuts for the shaggy dog look made popular by the Rolling Stones and the Beatles.

SPIRITUAL TRESSES

In some cultures, hair has traditionally had a deep significance, and is not just a matter of personal preference or fashion.

* For First Nations people, hair has long been seen as a gift from the Creator; choosing not to cut it is a means of extending their prayers and expressing their spirituality.

* Members of the Sikh religion have also historically viewed hair as a sacred symbol of faith and humility, never to be cut.

* Tribesmen in New Guinea believe that the ghosts of their ancestors reside in their hair. In their culture, baldness is interpreted as a sign that your ancestors have abandoned you!

Even though men's hairstyles haven't received quite as much attention over the years as women's, guys haven't been spared the anxiety of bad hair days. When the great French general Napoleon met with Czar Alexander of Russia in the early 19th century to discuss European politics, the two leaders apparently ended up swapping stories about remedies for baldness, an affliction that affected them both.

During the 17th and 18th centuries, European aristocrats wore

enormous wigs—this is where the expression "bigwig" comes from. The most impressive of these were invariably "powdered" to make the hair appear gray or even white, which was considered especially attractive at the time. In contrast to today, people believed that women's beauty, in particular, was enhanced by gray hair, as it made them seem younger and softer.

Male or female, those with the time and money to labor over their appearance created elaborate hairstyles on the tops of their heads, with or without the aid of wigs. In order to achieve the kind of height they wanted, they stuffed the hairdos with wool, kept it all in place with wire, and even decorated the end result with small ornaments. Some of these creations were so high that, in 1780, the doorway of St. Paul's Cathedral in London had to be raised by four feet in order to accommodate their version of "big hair."

The use of flour as both hair and face powder became controversial leading up to the French Revolution in 1789. Chronic food shortages among the peasants—caused in part by the aristocrats hoarding flour for cosmetic reasons—resulted in riots. The introduction of the guillotine—that famous French invention used for

SHOCKING CHINCHILLA OR SEXY TURN-ON?

Dressed in a designer evening gown for the premiere of her new movie, Julia Roberts raised her arm to wave to the assembled crowd. The cameras clicked furiously, and the next day the scandalous photograph was reprinted in newspapers all over the world.

Ms. Roberts had committed one of the most serious beauty crimes possible— in North America, at least: she had failed to shave her armpits.

"You'd think it was a chinchilla that I had under there, the way the world responded," she said to a friend. But Ms. Roberts was obviously more interested in her then boyfriend's response than the world's. Like many Europeans, American actor Benjamin Bratt reportedly preferred the natural look.

lopping off people's heads—helped turn things around. Faced with the prospect of being asked, "Your flour or your head," the rich stopped hoarding.

CAUTION: CURVES AHEAD

IN HER DAY, she was pursued by famous athletes, writers, and politicians (including one president of the United States). Now, more than 40 years after her death, Marilyn Monroe is still considered to be one of the most desirable women of all time. Although her hit movies are so old they were filmed in black and white, to millions of people she remains *the* screen goddess.

But here's the thing: if Marilyn Monroe showed up as an unknown today looking for a job in the movies, she'd probably be sent packing from the gates of every studio in Hollywood. They'd direct her to the nearest weight-loss clinic. If she was lucky, she might get to play somebody's sister or eccentric aunt, but "glamorous heroine" probably wouldn't make it onto her résumé.

This is not to say that Marilyn Monroe was fat—it's a relative thing: next to most contemporary supermodels, we're all "fat"! But in contrast to the beanpole profile that's popular today, she was 5 feet, 5½ inches tall and reportedly weighed as much as 140 pounds during her career.

How does the definition of "great body" change from one generation to the next? And who decides when thin is in or slightly fat is where it's at?

The truth is that for most of recorded history, the women considered most beautiful have *not* been so thin that they had to run around in the shower to get wet. Traditionally, plumpness was seen as a sign that a girl or woman had high social status and enough money to ensure she wouldn't starve. Ample curves on a woman were also believed to reflect a good sense of humor and an easygoing nature. As recently as the 1890s, scrawny women were considered in North America to be mean-spirited and bad-tempered.

But all sorts of events in the 20th century changed how people thought about beauty, especially in the Western world. And in response to those events, some aspects of physical appearance became more important than others.

Now You See 'Em, Now You Don't

Breasts, for instance: unless they've lost one or both, say to cancer, all women have them, and—like other parts of our bodies—some people's are bigger than others. From one woman to another, breast size can range dramatically, even among sisters.

And yet breasts have gone in and out of "fashion" over the years. In some eras, necklines were designed to focus attention on them, and at other times, women were expected to hide them and pretend they didn't exist. This is hard to imagine today, when ads for everything from blue jeans to automobiles seem to focus more attention on women's chests than they do on the products being sold.

But just for a moment, think about how crazy it is that a *body part* can one day be declared "unfashionable."

Most of us have two thumbs. But imagine if someone decided one day that they were no longer "in," and that it would be better if we didn't admit to having them. Clothing designers would create special gloves or complicated sleeves that made them look smaller, or covered them up altogether. Doing anything that required manual dexterity would be made much more difficult: eating, riding a bike, playing video games—not to mention getting dressed in the first place.

Now, it's true that women's breasts aren't quite as functionally necessary as thumbs, except when feeding a baby. But it's still bizarre to consider that they were meant to be neither seen nor spoken about during certain historical periods, and some of those occurred in the last hundred years.

How and why did attitudes change so much over the space of

a single century? It helps to know a bit about the way society has historically viewed women, and what they were expected to be and do...

1890s Throughout the 1800s, the corset was a wardrobe "must" for fashionable North American women: they had to tightly lace the cumbersome undergarments around their torsos to make their waists look smaller and their busts look larger. This made moving around very difficult, which had the added social benefit of keeping women "in their place"—mostly at home! Additional help on the bust front was available in "falsies" (padding or fake breasts), since voluptuous women with large bosoms were seen to be healthy, modest, and good. The most celebrated beauty of the late 1800s, singer/actor Lillian Russell, was said to weigh close to 200 pounds. In contrast, thinness was sometimes seen to be the mark of an indecent and dangerous woman, and even the internationally famous French actress Sarah Bernhardt was mocked for having the figure of a broomstick.

In the late 1890s, singer/ actor Lillian Russell's significant size—she weighed as much as 200 pounds during her 30-year career—was no obstacle to her being considered gorgeous. She headlined in musicals in New York City, where her most famous role was as the lead in a production titled *The American Beauty.*

1910s Within the space of 20 years, standards shifted dramatically. In 1908, Parisian designer Paul Poiret created a new, slimmer style of dress and announced, "From now on, the breast will no longer be worn." Easy for him to say! Then World War I gave many women their first opportunity to get jobs. Around this time, many Western countries also granted white women the right to vote in

In the 1910s, designer Paul Poiret declared that breasts were "out" and fashioned clothing for women that focused attention elsewhere. His sheath dresses didn't require corsets, and presented a much less curvaceous silhouette that, as he said, "freed the breasts."

elections. Women began to feel increasingly independent, and free to choose whether they wanted to work outside the home or not. One thing they chose in droves was to abandon restrictive corsets. This alone gave them enormous freedom to move, and was reflected in the popular flapper look of the 1920s. But in order to achieve the flat-chested profile of the modern flapper, many women had to bind their breasts tightly against their rib cages to make their figures look more boyish. Also, the shiftlike dresses were often sleeveless, and much shorter than previous styles. This made women much more self-conscious of their arms and legs, and the suddenly popular slim look gave birth to the 20th century's first dieting craze.

1950s After World War II, women were encouraged to give up their factory jobs to ensure returning soldiers had work. Governments and retailers in the US and Canada encouraged women to focus on activities considered to be more

Although the identical dresses worn by contestants for the 1959 Miss Rheingold title didn't hug their figures or show much skin, their full skirts and cinched waists reflected the curvaceous profile of the time.

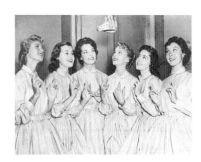

feminine—like worrying about their looks, and cooking and cleaning! Popular movie stars like Marilyn Monroe and Jane Russell made having curves fashionable again, and doctors suddenly started diagnosing "small breasts" as if it were an illness, and recommending plastic surgery.

1960s Then in the 1960s, British fashion model Twiggy became all the rage almost overnight. Her nickname reflected how incredibly thin she was—although 5 feet, 6 inches tall, she reportedly weighed only 91 pounds—and the *New York Times* described her as looking "just like your next door neighbor, if he happens to be a skinny 12-year-old boy." The new woman-as-child fashion ideal emerged just as some women were starting to write books and organize rallies to argue for greater equality between men and women. Some social critics believed there was a connection. They argued that fashion was being used to keep women in their place, to focus their attention on dieting to achieve the right body shape—instead of on lobbying to be paid the same wages as men.

1980s Twenty years later, breasts—both natural and artificial—made a fashion comeback. Some people credit women's increasing power in the workplace for the change, which was also reflected in dress and blouse styles that included big shoulder pads, designed to help women appear more authoritative at the office. Others point to the fact that cosmetic surgeons were promoting the wider availability of silicone breast implants. And healthier-looking models like Christie Brinkley and Cindy Crawford represented the ideal of the strong All-American girl. Whatever the cause, curvy chests were again popular.

1990s	By the following decade, both extremes seemed to be competing for attention. On the one hand, cosmetic surgeons claimed that the pumped-up profiles of popular stars like the surgically enhanced Pamela Anderson were responsible for the continuing trend toward bigger breasts. On the other hand, the waif-like Kate Moss, who was so skinny she sometimes resembled a child, had become the supermodel of the decade. The wasted "heroin chic" look became so popular in the media that health professionals started expressing concerns about the rising rates of eating disorders among young women.
circa 2000	At the end of the century, the "fashion" in women's breasts and what they should look like had become more fickle than ever before.

Is your head spinning over all these style shifts? Are you wondering how anybody is expected to keep up in a world in which the body you inherited may be deemed "with it" one year and unfashionable the next? One thing that does seem certain is that the only people who can really win at this game of revolving-door ideals are the ones who earn their living in the beauty business.

BODY IMAGE GOES GLOBAL

OUR DEFINITIONS OF WHAT'S GORGEOUS and what's not haven't just changed over time; they also vary dramatically from one culture to another. The movie example of the African bushman repulsed by the blonde who's so pale she "looks like she just crawled out from under a rock" is just one indicator of this. Contrast North American beauty standards with some of the attitudes found in other countries:

* In modern, urban Brazil, large bottoms and small breasts are seen as desirable assets.

* The ideal Ugandan woman weighs about 150 pounds.
* Native Peruvians and many Nigerians consider especially full-figured women beautiful, whereas the same bodies might be seen as overweight in North America.
* The French are generally more focused on fashion and makeup than body image, and are disdainful of North America's obsession with thinness.
* Some African tribes make deliberate cuts to their skin in order to create "beautiful" scarring.
* In other countries, young people deliberately wound themselves, puncturing the skin on their face or body with pieces of metal. (Oh, wait a second, those countries include Canada and the United States!)

But North American culture is being exported all over the world faster than ever. As a result, the definitions of beauty held up as ideal in TV shows, advertisements, and movies produced here are being imposed on other cultures. Now, even in some Asian and African countries, where the vast majority of people have dark hair, skin, and eyes, the models celebrated as being the height of beauty are often blonde-haired, blue-eyed, and pale-skinned.

Who benefits from this? Certainly not Asians and Africans. In trying to sell North American products, the media

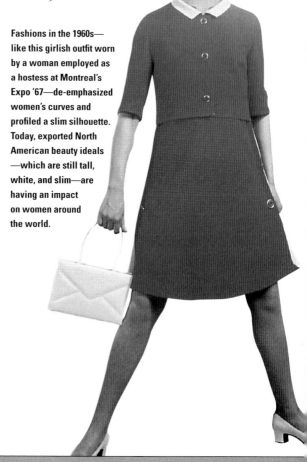

Fashions in the 1960s—like this girlish outfit worn by a woman employed as a hostess at Montreal's Expo '67—de-emphasized women's curves and profiled a slim silhouette. Today, exported North American beauty ideals —which are still tall, white, and slim—are having an impact on women around the world.

messages end up suggesting to millions of people that not only are they not beautiful the way they are, but they can never even hope to *become* beautiful, because they don't have the right set of genes to start with.

And yet North America's unrepresentative scrawny ideal is also being exported. Up until TV was introduced into Fiji in 1995 (and by TV we're talking *American* TV), eating disorders were unheard of there. Three years later, one study found that 15 percent of girls had tried vomiting to lose weight. Our television shows had effectively taught young Fijian women not only to hate their naturally curvy bodies, but also the dangerous techniques that lead to eating disorders.

People who have traveled all over the world will tell you that teenagers in Tanzania have different ideas about what's hot than their counterparts in northern Thailand, downtown Moscow, the upper Amazon, and the highlands of New Guinea.

Even within North America, definitions of beauty can be tremendously diverse. Both Canada and the United States are made up of immigrants from all over the world whose skin, hair, and eyes reflect a rainbow of colors, and whose body preferences and fashion practices have been shaped by dramatically different cultures. It's just that most of the images

THOSE DOG-EYED WESTERNERS

Asian eyes differ from Caucasian eyes; in addition to being darker, the eyelids have less skin. In North America, this has led some Asians to feel self-conscious and to seek plastic surgery to make their eyes more "Western." But in the 1860s when Japanese people came into contact with Westerners, they thought that the Western women's eyes looked like "dogs' eyes"!

When Chinese and Tahitian people first met Europeans, they found the noses of the French and British—which were very long compared to their own—supremely unattractive.

Meanwhile, in some African countries, people believe that the human body, if it is unadorned with tattoos, scarring, or other decorations, is too close to that of an animal to be considered beautiful. The Maoris in New Zealand hold a similar view of women's faces: untattooed, they're just not seen to be very appealing.

seen in mainstream TV shows and movies don't reflect this.

But there *are* signs that our culture could be changing—even in the unlikeliest of arenas, big business. As one makeup industry executive says:

I'm committed to proving that beauty has no single look. Beauty can be both a …black transvestite or a woman like kd lang without a hint of makeup.

—Frank Toskan, founder of MAC cosmetics

THE RULES OF ATTRACTION

THERE ARE MORE THAN SIX BILLION PEOPLE in the world, and only a couple of dozen of them are supermodels. Their faces and bodies are promoted as the height of desirability to which we should all aspire. Realistically, most of us won't even come close. And yet every day you can open up a newspaper in your hometown and find wedding announcements. Or walk down the street and see couples holding hands, pushing baby carriages, or just hanging out.

Very few of these people measure up to the images of perfect-looking men and women you see in the media. (In fact, as we'll see in chapter 9, not even the men and women in the media live up to their own images!) But there it is: irrefutable evidence that you don't have to be a supermodel—or even fabulous-looking—for other people to find you attractive. Amazing, but true: ordinary guys and girls—who may have big thighs or thin lips, frizzy hair or small eyes, narrow shoulders or a big butt, the occasional zit or a bump on their nose—find people who think they're beautiful.

Why is that? Well, all sorts of things besides skin tone, muscle mass, and body shape influence whether or not we think someone is good-looking. Probably very few of the people you hang out with fit the Johnny Depp or Lucy Liu mold. Their "beauty" might be reflected in their intelligence, confidence, sense of humor, or personal style.

And increasingly, our ideals are becoming a whole lot more diverse—and more interesting, too. Some fashion designers—always looking for a way to take advantage of emerging trends—have even coined a new expression to define the next generation of models: "EA" stands for "ethnically ambiguous"—an anti-cloned look sought by some advertisers who want their images to stand out from the crowd.

IMAGE REFLECTIONS

SO WHAT DOES BEAUTY being in the eye of the beholder really mean? Basically, that it's up to you—and me, and him, and them and her... We've all got opinions, and a lot of them clash.

* Just as it's impossible for people to agree on "the best movie or book of all time," a single definition of beauty doesn't exist.

* There's simply no predicting. Throughout history and across cultures, people have responded to all sorts of different qualities—both physical and emotional—when checking out one another's looks.

* Tape measures can give you dimensions, but they're almost useless for judging beauty.

* Most of the images we see in the media reflect only a fraction of the beauty diversity found in the real world: it's like we're being fed a diet of vanilla ice cream all the time, and being denied everything from chocolate and maple walnut to mango and capuccino—which many people find equally or more appealing!

STONE AGE PERSONAL AD

Good Hunter
Very strong and
fast as the wind

MODERN PERSONAL AD

Attractive guy
with cool clothes
and attitude.
Babe magnet

THE YOUNG AND THE HEALTHY

Ever heard the expression, "Age before beauty"?

In three small words, it sums up a common assumption: age and beauty are mutually exclusive. If you're old, then by definition you can't also be beautiful—because youth is an essential ingredient.

This may be difficult to appreciate when you're just trying to survive adolescence: your voice is changing, your skin is oily, the current with-it hairstyle takes way more time than you're prepared to spend. And the fashions being worn by this week's MTV star—not to mention half the kids at school—aren't remotely you.

Contrary to the collection of serious flaws you may see in the mirror, chances are that many of the adults around you see vibrant, glowing youth. But they also know you probably don't appreciate the enormous beauty advantages of being under 25.

THE UNDER-25 EDGE

Try plump lips, wrinkle-free skin, and a full head of hair. Add good muscle tone, easy grace, and energy. These are all very appealing features, found more often in the young than in the middle-aged or elderly. And even though you may not have noticed, advertisers sure have. That's why a lot of campaigns are geared to reminding older people that their lives would be *sooo* much better if they looked more like you.

With age, the qualities of youth tend to fade. Sun damage and life experience create wrinkles, hair turns gray or falls out,

COME DRINK AT THE FOUNTAIN OF YOUTH

The uplifting articles in Oprah Winfrey's magazine are written to encourage middle-aged women to love themselves the way they are and to take inspiration from community achievers. *O*'s editorial content is free of the typical beauty and fashion fare found in most other women's magazines. And yet, on its very first page, Estée Lauder invites readers to imagine being able to "welcome the ageless future" through using "Perfectionist Correcting Serum for Lines/Wrinkles," while on the back cover, Lancôme promises that "Renergie Lift Makeup" will help "make up for lost time," by allowing users to become "younger-looking instantly."

Meanwhile, TV commercials for everything from Viagra to Botox to hair dye take as a given that adults would like nothing better than to be able to turn back the clocks and recapture their once gorgeous and energetic youth.

You probably never even register these ads, but for people over 30, the message is inescapable: they're on the downhill slide away from their peak beauty years, and it's not pretty!

From the advertisers' perspective, this is good news: since everybody ages, and most of us buy into the notion that beauty equals youth, there will always be lots of customers for the products they're selling.

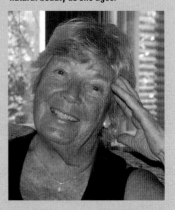

Award-winning writer and social activist June Callwood has always invested more energy in living a passionate life than she has worrying about wrinkles. She has retained her natural beauty as she ages.

muscles grow slack from lack of use, and gravity pulls any extra weight gained toward the belt (think of it as the Santa Claus effect). In pursuit of product sales, advertisers invest a lot of time pointing out how unattractive these features are.

So next time you're feeling critical of your minor imperfections, take heart: you have wrinkle-free skin, an absence of gray hair, and you probably wouldn't recognize an age spot if you tripped over it!

BEAUTY SURVIVORS

IF OUR CAVE-DWELLING ANCESTORS had been able to place personal ads in their hunt for a mate, the women's ads probably would have read something like this:

> WANTED: INTELLIGENT JOCK—Fast enough to outrun wild animals, smart enough to outwit them, coordinated enough to hunt them, and strong enough to carry the dead ones home. Big and tough—but not so tough that you'll frighten the kids.

The guys' ads would no doubt have been a bit shorter:

> MOTHER NEEDED—Healthy: able to get pregnant, give birth, and feed kids.

Unlike the personal ads of today, the emphasis might not have been on superficial appearances. The name of the game was survival, and youthfulness and good health were key to ensuring that. As a result, they became essential ingredients in defining a person's attractiveness. Many centuries later, they still are.

One psychologist puts it this way:

Beauty is health. It's a billboard saying, "I'm healthy and fertile. I can pass on your genes."

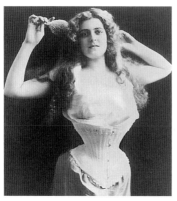

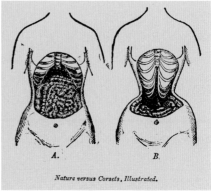

By accentuating the contrast between the smallness of a woman's waist and the largeness of her hips, the corset focused attention on her capacity to bear children.

Even if you had a rib or two removed to make wearing a corset more comfortable, the device seriously compromised your internal organs.

Nature versus Corsets, Illustrated.

This theory argues that beauty is not so much in the *eye* of the beholder as it is in the *circuitry* of the beholder. In other words, some people claim human brains are hard-wired to be attracted to young and healthy bodies that appear to be able to help us have children.

The notion of this ideal dates back to Charles Darwin, the 19th-century British naturalist who developed the theory of evolution. His writings on natural selection tried to explain how different species developed the way they did. He argued that over the course of millions of years of evolution, certain physical features and behaviors triumphed because they served a purpose in helping animals or humans to escape the dinosaurs' fate. Other traits and characteristics disappeared because those displaying them weren't "selected" as often as mates.

Darwin's selection theory has had a lot of influence over how we think about beauty. It suggests that physical attraction is nature's way of ensuring that a species survives.

But we've evolved over the millenia. Most of us are no longer

hunting wild game for our supper or rubbing two sticks together to make fire. We don't need to use a cave dweller's criteria when choosing a partner. Our selection process has become much more sophisticated and our attractions to other people are no longer driven by biology. We have sex for more reasons than just to have kids.

And yet old patterns are apparently difficult to shake; the way we judge beauty today obviously has its roots in the past.

FACE FIRST

TAKE SKIN, FOR INSTANCE.

Even though acne still ranks high on most teens' "things that suck" list, people's skin used to be vulnerable to a whole whack of other problems as well.

Before the days of antibiotic medicines, invented in the 1940s, many infectious diseases like chicken pox or measles ravaged people's faces. As a result, those with clear, smooth, and even-toned skin were seen as disease-free—and more beautiful.

In northern cultures of light-skinned people, pale skin became especially prized because it allowed

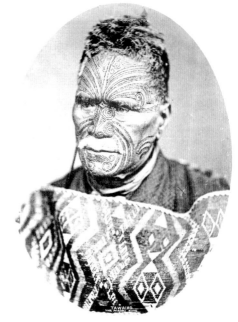

The scars and tattoos on this man's face were seen as beautiful in traditional Maori culture, and as marks of civilization; they also provided evidence of his healthiness.

you to more easily detect signs of disease. In contrast, darker skin would better conceal evidence of smallpox or jaundice.

But light skin burns very easily and so in especially sunny climates, it's an unhealthy disadvantage. Dark skin evolved as protection against the sun, and people living in hotter places

developed different beauty rituals to help them identify who was healthy and who wasn't.

Maoris and many African tribes practice "scarification"—they deliberately cut themselves and then pour dye, fruit juice, or other irritants into the cuts to inflame them. When the cuts heal, they leave welts. Among many dark-skinned peoples, these permanent welts are seen as beautiful, as marks of civilization. In addition, the scars provide evidence that those boasting them are healthy. The idea is that if their bodies were able to withstand the cuts and the irritants and heal effectively, then they must have good immune systems, capable of warding off disease.

Best Face Forward

Healed wounds are one thing. But the actual sight of disease—even on a small scale—often inspires a built-in recoil reflex.

Here in North America, whether you seriously gash your leg in a skateboard accident, wake up to a honking red cold sore on your lip, or discover that the ring in your ear has been swallowed up by a pus-filled infection, you're probably going to want to hide the evidence of your body's momentary descent into unsightliness.

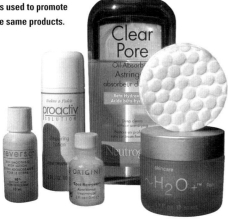

Your local department store offers a dizzying array of skin care products, all promising to help you achieve the kind of flawless faces used to promote those same products.

Thank goodness for hats, pants, long hair, and—if you're female—makeup.

Tim, who's 17 and battles the occasional prominent pimple—usually right on the end of his nose, is convinced that whoever manages to create a concealer that they can persuade guys to use will make millions.

He's probably right. The skin care industry does make millions. Disfiguring diseases like leprosy and smallpox may be unheard of in

HAIR TODAY, HEALTHY TOMORROW?

Like skin, great hair has typically been interpreted as a mark of good health and therefore of beauty. But today's continually expanding options mean there's less agreement about what constitutes "great hair" than ever before.

And context is critical: a style or color that flatters one person doesn't always suit another. Computer programs can now eliminate the guesswork, but nature imposes a few restrictions. Some types of hair are more resistant to perming, straightening, or coloring than others.

With the advantages of youth on their side, some young people reject the "crowning glory" status traditionally assigned to hair altogether, shaving their heads to make a statement.

North America, but the makers of cover-up, cleansers, bronzers, foundation, and facials all capitalize on our desire to put our best, blemish-free face forward. Even though the things likely to affect our skin are much less life-threatening now, our attachment to making sure we look healthy and blemish-free remains as ingrained as ever.

If you believed all the advertisements you read, in a single trip to the drugstore you could pick up three products that together would overcome the chronic teenage battle. First you'd use the "thick dual-sided cloth [which] instantly exfoliates and cleans deep into pores," next you'd apply the stuff guaranteeing "oil control that lasts for hours," and then you'd be sure to add nightly sessions with the product that's "dermatologist proven to help prevent breakouts."

... And yet if the results promised by all the products available are so certain, how come pimples still plague us?

DECEITFUL LOOKS AND CHANGING CUES

BUT HERE'S THE GOOD NEWS. People are not *really* wandering around, unconsciously judging your physical appeal on the basis of some stone-age value system that isn't relevant in the 21st century. Unlike dinosaurs, human beings didn't perish, we *adapted*.

In fact, relying on the narrow set of cues that our cave-dwelling ancestors used to judge health, beauty, and the ideal mate would be risky business in North America today.

For one thing, we've invented all sorts of ways to fake beauty— from makeup and hair dye to face-lifts and liposuction. Who knows what's real and what's been bought and paid for anymore?

Secondly, North American communities are much larger and more racially diverse now than the small groups in which our ancestors lived. Today, features that might have predicted health in one race thousands of years ago—like size or skin color— have now been influenced and altered in combination with those of

Entire books have been devoted to our fascination with blonde hair, which is quite rare in nature. The majority of "blondes"—like this woman in the midst of a highlighting treatment—need a bit of chemical assistance. Some suggest that part of the appeal of light hair is its association with youth, since many more children are naturally blonde than adults.

other races. As a result, they may no longer be reliable indicators of health.

Some scientists argue that even though we consciously realize all these things, parts of our brains haven't caught up to 21st-century reality. They say we're still programmed to respond to the same kinds of cues that got our ancestors excited.

But others say we make decisions every day that override our genes' default mode of ensuring the survival of the most beautiful. And there's evidence of that all around.

New Criteria

In 21st-century North America, we may actually pay *less* attention to visual health cues than we used to. In the late 1980s, a psychologist interviewed more than 10,000 people from 37 different cultures, asking them what they were looking for in a mate. Kindness topped the list. But physical attractiveness also ranked as important for most people. Interestingly enough, however, good looks ranked higher in many developing countries than they did among North American college students.

You might think that people who aren't bombarded by thousands of media messages every day encouraging them to dye their hair, eliminate their wrinkles, or tone their tummies might be *less* concerned about physical appearance.

But the psychologist conducting the study concluded that parasites, not supermodels, made the difference. In developing countries where parasitic diseases (everything from hair lice to tapeworms) are common, clear skin and beautiful hair are still good "advertisements" for health.

IN PRAISE OF... AVERAGE?

IMAGINE IF YOU WOKE UP ONE MORNING and stumbled into your bathroom only to discover that your regular mirror had been miraculously replaced by the kind of looking glass owned by Snow White's stepmother. Would you be tempted to ask it to rate your beauty? How would you feel if it pronounced you "average"?

Some studies have determined that average faces are actually deemed more attractive than others. Many fashion models *do* have very similar-looking—some might even say interchangeable—faces. But using the word "average" seems to contradict other common descriptions of beautiful people—such as when we say, "He's *extraordinarily* good-looking."

On the other hand, seeing "average" faces in the media helps to convince us that the look may be attainable. As a

THE PEACOCK SYNDROME

But wait a second... What about the peacock? What about those enormous, extraordinary tail feathers—nothing average about them. The thing is, although they may serve to attract peahens, the bigger and showier they are, the harder it is for the male bird to get around. Magnificent tail feathers may make one peacock stand out amongst others, but they also make it harder for him to survive.

In contrast to the "average = attractive" theory, exaggeration of one particular physical trait—even if the trait doesn't have a built-in health advantage—is also often seen as being beautiful in human beings, too. Especially large eyes, for instance, don't necessarily see better, but we tend to find them attractive.

result, some companies use people who are *ideal* versions of average in their ad campaigns. On a personal level, average might also translate into "fitting in," being part of your crowd, someone everybody else can relate to.

It seems to have a survival element, too. Research has found that in birds and animals, average proportions often reflect "good design," offering healthy advantages and longer life spans. Even in humans, babies who are born considerably larger or smaller than the average eight pounds are more likely to have health problems during their first year.

IMAGE REFLECTIONS

SO WHAT'S THE STORY? Do our judgments about what's hot come hard-wired into our brains or get handed down from cave-dwelling ancestors? Or have we managed to short-circuit them over time with "eye of the beholder" perceptions? Probably some of both. Here's what we do know:

* If you were born healthy, you already have an advantage in the beauty stakes.
* Who knew? Contrary to the publicity it gets, "average" may actually be more attractive than it sounds.
* Don't knock the benefits of youth: it may not feel like a powerful beauty weapon, but it is.
* Unlike some species, we humans adapted instead of dying off; in the process, we opened up all sorts of possibilities.

SUFFERING
IS
OPTIONAL

The French have an old saying: You have to suffer to be beautiful. And anyone who's ever spent 10 hours walking around in four-inch heels or woken up the day after a too-rigorous weight training session would probably agree.

Down through the ages and all around the world, human beings seem to have come up with an unlimited number of ways of inflicting pain on ourselves in pursuit of looking good. Some of these seem so bizarre we can hardly believe anybody would actually engage in them. But other, sometimes equally strange practices are so familiar to us we don't even think about them.

The question is, why?

THE CHRISTMAS TREE SYNDROME

"THE PAIN IS ONLY TEMPORARY, but the benefits last forever."

It could be the slogan of a tattoo parlor; instead it's just a common explanation for why people are prepared to be painted, poked, and punctured to achieve a desired look.

And not only here and now. Although we might think of makeup, piercings, and tattoos as recent trends, they've actually been around forever. Human beings' interest in self-decoration is one of the things that separates us from other animals. Cats may groom themselves and birds may puff out their chests and preen, but only human beings change the appearance of their bodies and hair with paint, jewelry, clothes, and—increasingly—surgery.

Are we born with some kind of vanity gene, or is it caught up in our sense of competition?

Tattoos are more popular today than ever before: 15 percent of adult Americans have one or more, but younger people are 10 times more likely to have a tattoo than their parents.

What, me work?

Some feminine beauty practices seem to be all about pointing out not just that "we're beautiful," but that "we're better" than others.

For centuries, a key way to do this was to flash your cash status by drawing attention to the fact that you were so wealthy you didn't have to work. The strategies varied in terms of how much pain they involved, but ranged from foot binding in China to skin-whitening and corset-wearing in Europe and North America. How did this work? In one way or another, the effects of such practices proclaimed: "I live a pampered life." Consider: people with crunched toes require servants to carry them around; Caucasians who were able to avoid working in the fields maintained pale complexions; and those wearing corsets were obviously not required to do labor of any kind.

From applied rhinestones to multicolored designs, today's estheticians offer a wide range of nail adornment options. Like many beauty practices, long decorated nails have typically signaled wealth and free time, since they're hard to maintain in jobs involving manual labor.

Can you think of any modern-day equivalents? Beauty choices that say, "I'm so special, I get to sit on my duff by the pool all day?"

What about long, elaborately painted fingernails? They're impractical and get damaged or in the way when you're doing any kind of work with your hands. And these days, in contrast to earlier times, a dark tan has come to be seen as a mark of free time, not evidence of hard work outdoors. The message it sends is, "I just spent two weeks drinking piña coladas on a tropical beach."

Independence Day

Still other beauty behaviors evolved as a means of marking the passage from childhood into adolescence, or adolescence into adulthood.

For some African tribes, certain scars are created specifically to show that a young man or woman has grown from one stage to another. One theory is that pain is a necessary ingredient of the ritual: living through it demonstrates that the person is mature enough to handle the challenges that face adults.

In North America today, we don't have any formal rituals to recognize teenagers' growing maturity—unless you count getting your drivers' license or being allowed to drink alcohol.

But some experts think that kids' interest in dyeing their hair,

piercing their body parts, or experimenting with other fashion choices are evidence of an ingrained impulse for rites of passage. They argue that because our culture doesn't provide such rituals—we don't send girls off to the fattening house, as they do in some parts of Africa and the Amazon, or boys out to kill their first wild boar—kids have to make up their own. They say that's why some teens engage in what sometimes seems to adults to be bizarre beauty behavior.

Clearly everybody's different—some have a low pain threshold, for one thing, and can't be convinced to pluck their eyebrows, let alone have their tongue pierced. And there are many pain-free beauty traditions that also tend to start in adolescence, just when we begin to get interested in sex.

So maybe it's as simple as wanting to attract a little attention, and looking for ways to enhance our bodies, faces, and hair. The options chosen just depend on the culture in which you live.

MAKING UP

IN NORTH AMERICA, girls have a lot more of those options than guys. The cosmetics ads that fill their magazines are so full of promises, it's no wonder women and girls are tripping over each other to line up at cash registers—literally. A few years ago during a makeup promotion at Bergdorf's in downtown New York City, the department store had to lock off one of its 5th Avenue entrances during business hours because women were in such a hurry to get to the cosmetics counter that they kept getting stuck in the revolving door!

Between the ad hype and the gift-with-purchase incentives, it's no mystery why we respond with such enthusiasm to these promises—the first time, anyway. Who wouldn't want an easy way to get rid of minor flaws?

No matter what your appearance, the beauty business has designed a product to address its deficiencies: moisturize dry skin

or dry up oily; eliminate blackheads or erase wrinkles; add body to your hair or tame frizziness; lighten dark skin or apply bronzer to a pale complexion… Spend too much time immersed in the beauty hype and you start to wonder if there's *any* condition or feature that's *not* in need of improvement!

DEATH BECOMES HER?!

It's hard to imagine cosmetics existing without magazine advertising and department store displays, but people have been slapping natural and unnatural substances on their faces for all recorded time—even when doing so proved deadly!

In pursuit of a pale complexion, women during the Middle Ages

In the middle ages, blood-sucking leeches were applied to people's skin for both health and beauty reasons. It was believed that blood-letting would rid the body of impurities, and that beauty meant having an especially pale complexion.

attached leeches (as in little slimy bloodsuckers found in lakes) to their faces. This drained the color from their cheeks (loss of blood tends to have that effect) and often caused them to pass out.

During the Renaissance, women achieved pale skin by applying lead mixed with egg white, lemon juice, or vinegar. You've heard of lead poisoning? Unfortunately, they hadn't; they experienced it instead, in the form of stomach pains, vomiting, comas, and sometimes even death.

When rosy cheeks came back into fashion in the 18th century, rouge made from sulfur and mercury was used—until it became clear that the concoction was causing inflamed gums and

Beauty's Lot

This satirical drawing from 1810, entitled "Beauty's Lot," comments on the deadly practices of the time, in which women applied poisonous substances like lead, sulfur, mercury, or coal tar to their faces in an attempt to achieve beautiful skin, rosy cheeks, or dramatic eyes.

tooth loss. Also, the coal tar employed as early eyeliner and mascara sometimes resulted in blindness.

Even the strangest concoctions for sale today are incredibly safe by comparison!

Words in Your Mouth

A study conducted back in the 1920s found that college students asked to describe and evaluate their own faces ended up quoting advertising slogans word-for-word—"a skin you love to touch," some said, or a "schoolgirl complexion"—straight out of then current campaigns.

Are you that easily influenced? Do you and your friends find yourself quoting some of the hype that typically makes up half of the average fashion magazine? How much of the stuff stashed away in your bathroom cupboard was bought on the strength of ad promises? And—more importantly—how many of the products delivered? In chapter 9 we'll look at some of the sneaky strategies behind the hype, and provide tips on how to avoid being taken in.

HAIR-FREE, NOT CAREFREE!

ANCIENT SUMERIANS USED TWEEZERS, Arabians used string, and Egyptians used beeswax and a mixture of starch, arsenic, and calcium oxide. There's even evidence that Paleolithic man shaved with sharp rocks and seashells. Regardless of which hair-removal method we're talking about, you can be sure that wincing and grimacing were involved.

Pity, too, the poor girls of the Elizabethan age: their mothers were inclined to apply bandages soaked in vinegar and cat dung to their hairline in order to get those high foreheads mentioned earlier. This is where the expressions "highbrow"—meaning sophisticated elite—and "lowbrow"—meaning ignorant hick—came from.

Aren't you glad you were born in the 20th century? Hair-removal technology has come a long way in the past 20,000 years. Unfortunately, given the tendency of hair to grow back, if your goal is the clean-shaven look, you still have to meet with your razor regularly.

In Queen Elizabeth I's day, around four centuries ago, if you didn't come by the desired "high-brow" look naturally, a little cat dung soaked in vinegar and placed on your hairline was said to help.

Other forms of hair removal are based on the same principle as weeding: if you tear the offending growth out by its roots, it takes much longer to reappear. So lots of people are prepared to have hot wax poured onto their legs, backs, arms, and chests—just to rip out hair that only a few decades ago was considered sexy.

Others swear by electrolysis, in which a needle is inserted into each hair follicle to electrocute the root. Laser treatments are similar in principle, but substitute a laser beam for the needle, and cause more trauma to your bank account.

Now that so many companies make money by convincing us that body hair is unsightly and embarrassing, it seems unlikely that the North American beauty business will reverse the trend and declare hairiness hot.

But you never know: hairy chests have been spotted recently in a few cologne ads. Maybe some energetic entrepreneur will figure out a creative way to make money by persuading people that body hair is desirable. Are you skeptical? It could happen: in other parts of the world, not only is chest hair on men still sexy, but leg hair on women is also considered the norm.

CHEST RUGS

Actor Burt Reynolds, the first male "centerfold" to pose nude in a woman's magazine in the 1970s, was covered in body hair. And women were wild about him.

Contrast that with the '90s, when Austin Powers' chest "rug" became an object of ridicule, and today, when most of the guys flogging cologne or underwear in glossy magazines appear to be completely hair-free. It's no coincidence that the same publications feature all sorts of ads promising to get rid of body hair, regardless of where it grows.

BRING ON THE NEEDLES

EVEN THOUGH YOU DON'T SEE A LOT OF SENIOR CITIZENS with multiple piercings or visible tattoos, the practices have been around for centuries.

But until very recently in Europe and North America, tattoos had gained a reputation as being the decoration of choice for sailors, truck drivers, and members of biker gangs. They were seen as a mark of machismo, a proclamation of their wearer's ability to withstand pain like a "real" man. They certainly didn't appeal to teenage girls, and you couldn't get one at your local shopping mall. As for piercing, it used to be confined almost entirely to earlobes.

Now that both have become much more mainstream in North America, the question is often not if, but what or where?

On the tattoo front, depending on whom you hang out with, or what kind of style statement you want to make, the options range from a discreet horoscope sign on your lower back, to a barbed-wire effect around your bicep, to the in-your-face approach that sees your forearm double as a scene from a martial arts movie.

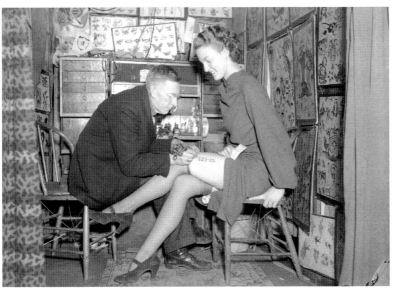

She may not look like it, but this woman getting a tattoo in the 1930s was engaging in a radical act; at the time, tattoos were largely something seen only on circus performers or men in military service.

Meanwhile, piercings have gradually expanded their territory. Now people seeking to make an edgier fashion statement—or differentiate themselves as being somehow "anti-fashion"—are going for tongue studs, eyebrow or cheek rings, or piercings through their nipples or the backs of their necks.

And the beauty impact? It definitely comes down to an "eye of the beholder" thing: opinions are all over the map. One person's enhancement is another's radical disfigurement. You might turn off as many people as you turn on!

Maybe that's part of the appeal. Getting some needlework done isn't quite as difficult as the kind of maturation rituals you might go through in a tribal culture, but it's not without risk. Some piercings are particularly tricky: tongue studs, for instance, can cause havoc in your mouth, damaging teeth or developing persistent infections. Safety issues also come into play any time needles are involved.

WHAT WAS I THINKING?

How about the second-thought issue? Five or ten years down the road, will you be wanting to make an entirely different beauty statement? About 10 million people in the US were expected to have their tattoos removed in 2004, mostly through laser surgery. And the removal process is often more painful than getting the tattoo in the first place.

BREATHLESS BEAUTIES

DID YOU HEAR THE STORY about Cher having two of her ribs removed to make her waist look narrower?

It's an urban myth, a great rumor that's just not true. But it's believable because not only has Cher had other "work" done on her body (she calls herself "the female equivalent of a counterfeit bill"), in the 19th century some women *did* have their ribs removed in pursuit of the desirable hourglass silhouette. And in the 16th-century French court, ladies-in-waiting were expected to cinch their waists to a maximum of 13 inches around. (Even

appreciating that women's bodies at the time were much smaller than they are today, that was still pretty extreme.)

In the early 1990s, Madonna tried to bring back the uncomfortable corset as a style statement but, fortunately for anybody who likes to eat, the punishing undergarment never really made a successful comeback.

Compared to the kind of clothing-induced torture that used to be commonplace in the Renaissance, too-tight jeans that temporarily cut off the circulation in your thighs and sexy but uncomfortable underwear that gives you a wedgie all day long may feel like small prices to pay for looking good.

IF THE SHOE FITS...

DEPENDING ON WHOM YOU ASK, women's shoes may be the most torturous beauty custom of our day. Although foot binding was banned in China decades ago, some of the most fashionable shoes North American women suffer in today make you think the practice is alive and well.

Whether your budget accommodates high-end designer shoes by Jimmy Choo or bargain basement knock-offs, high heels come in everything from four-inch stilettos and chunky platforms to the wedge look. Although some feature square or rounded fronts with plenty of wriggle-room, others boast toes so sharply pointed they could double as weapons.

And even though they all lack the comfort of a pair of cushioned runners, plenty of young women are happy to experience a little discomfort in exchange for the perceived benefits. High heels, in addition to offering greater height and more defined calf muscles, also alter a person's posture. Bodies not designed to be strapped into mini stilts adapt by thrusting out the buttocks and chest bones in search of balance. Small wonder lots of guys reward the wearer with a little extra attention.

Unfortunately, wearing high heels can have major drawbacks.

Buying a pair of Manolo Blahniks will not only set you back as much as $1000 and imperil your balance, but the shoes come with side effects. These may include hammertoes, permanently contracted muscles and tendons, nerve damage, and bone fracture. Ouch!

But for lots of young women, the risks seem too far down the road to worry about. Chic fashion magazines and popular TV shows have made high heels so much the rage that even some people who have already seriously damaged their feet are willing to take further risks in order to continue wearing them. A growing number of American women are turning to surgery—not to correct the problems caused by heels, but to have the bones in their feet shaved or shortened so they can get back into the punishing shoes.

The practice of foot-binding, one of many customs that reflected the inequality of the sexes, resulted in broken bones and stunted growth, which eventually crippled the Chinese and Egyptian women whose feet were trapped inside tightly wound fabric. The problems caused by today's stilettos seem tame by comparison.

The results aren't always pretty. More and more foot doctors say they're seeing patients with problems resulting from such cosmetic procedures. One woman recently featured on the front page of the *New York Times* expects that as a result of her surgery, she'll never again be able to wear anything other than orthopedic shoes—which was not the fashion statement she was looking for.

UNDER THE KNIFE

FROM STREET FIGHTS IN THE 16TH CENTURY to prime-time television today, plastic surgery has come a long way.

It was first invented to patch up the faces of young Italian men who used knives instead of fists to resolve their drunken differences on Saturday nights. Then in the late 1800s, the sexually transmittable disease syphilis began to spread, eating away at its victims' noses. Plastic surgery was often sought to correct the damage.

But it wasn't until the 20th century, as surgery and anesthetic techniques became more sophisticated, that it became common. In World War II, soldiers were coming back from the European front with their faces so damaged that they were unrecognizable. Surgeons, in addition to trying to save their lives, did everything they could to patch up their faces. Newspaper headlines often characterized the results as nothing short of "miraculous."

The result? Healthy people began considering cosmetic surgery as a possible means of looking more attractive, a perspective encouraged by many of the surgeons themselves. These days it's become such a widespread beauty practice—in 2003, Americans underwent 8.3 million cosmetic procedures—that it's advertised in daily newspapers and has been the subject of several TV series.

Suck it Out

The description of liposuction sounds a bit grisly: essentially, fat tissue from beneath your skin is vacuumed out. When it was first

made available in the US in the early 1980s, a dozen patients died as a result of the treatment within a couple of years.

It's safer now than it was then, and hundreds of thousands of Americans have liposuction every year. Because our culture is so critical of people who are overweight, you can understand why an operation that can get rid of fat overnight—no dieting or exercise necessary—is appealing. And some fat deposits—the so-called "saddlebags" or "love handles" people may develop on their hips or waists—often don't respond quickly to dieting or exercise regimes.

But there are still major risks involved, including excessive bleeding, blocked blood vessels, punctured organs, and occasionally death. And having liposuction in one area doesn't prevent the fat from bulging out someplace else. Nor does it help you start working out to avoid gaining more.

Cow Fat, Anyone?

Now this would be a night to remember: say you opened the mail one morning to discover you'd been invited to a party that involved paying $500 for the privilege of having someone inject a needle full of cow fat into your face. Would you go? In some circles, such get-togethers have become all the rage.

The companies selling these treatments refer to the cow fat as "collagen," which is a protein also present in human beings' connective tissue. The scientific name does make it sound a bit more appealing, and the effect of the treatment is to plump up your lips. Since full lips are seen as youthful and sexy (think Angelina Jolie or Scarlett Johannsen), collagen injections are supposed to make you more beautiful.

Middle-aged movie stars like Melanie Griffiths and Meg Ryan have had such treatments, with mixed results. Some observers believe that the injections can so alter a person's face that they no longer look normal, or like themselves. The good news (or bad, depending on your perspective) is that the cow fat only stays in

your lips a couple of months; then you have to pay another $500 for a second treatment to maintain the look.

Bacterial Beauty

Botox works on a similar principle: injected into wrinkled areas of a person's face, it plumps up the skin around the wrinkles and seems to make them disappear—if only temporarily. At the same time, it paralyzes the facial muscles so you can't reinforce the wrinkles.

Instead of consisting of cow fat, it's made up of minuscule quantities of the deadly "botulinum toxin 'A'," a bacteria capable of killing people in much higher doses. Based on 15 years of experiments on humans, researchers believe that Botox treatments are safe. And they can be effective at creating a more youthful appearance.

On the downside is the fact that when your facial muscles are paralyzed, your face is much less able to express emotions. Depending on how much Botox has been used, you can no longer raise your eyebrows or even smile.

All I want for grad is my two front… boobs?!

Ever since Pamela Anderson bounced her bikini-clad body down a California beach, breast implants have been growing in popularity. In fact, in some wealthy school districts, they've become the graduation gift of choice for girls. Once considered a fairly radical procedure designed primarily for women who had lost a breast to cancer, breast implant operations in the US increased *seven*-fold between 1992 and 2002, from 32,607 to 225,818.

During that time, Anderson herself had her implants removed and replaced, and supermodel Iman confessed publicly that she found her own operation extremely painful. Almost all implants (saline and silicone) eventually rupture and have to be removed. And it's an expensive process. The average surgeon in the US

charges $3,300 for implants, not including hospital fees and follow-up care. Removal can cost $8,000 to $10,000.

For some, the question is, how do you measure such physical pain against the anguish of having the football team vote you the "flattest" girl in your school? The numbers suggest that more and more women are deciding that having the kind of cleavage that makes guys drool is reason enough to take the risks. In sunnier parts of North America especially, where people wear fewer clothes all year round, there's lots of pressure to have the kind of figure that would be at home in the *Sports Illustrated* swimsuit edition.

TOO MUCH OF A GOOD THING

Breast reduction surgery doesn't have quite the same headline appeal as implants, but for many women, young and old, it's the operation they're after. Especially large breasts can bring unwanted sexual attention and comments, make buying clothes an exercise in frustration, and cause chronic neck and back pain.

After reduction surgery, in addition to feeling better, many women report how wonderful it is to have men look them in the eye, instead of being distracted by their chest.

And yet, studies have found that most women who choose to have surgery say they don't want to look like screen sirens, they just want to look "normal."

The trouble is, when so many women are getting implants, buying push-up "miracle" bras, or being graphically enhanced in photos, it's impossible to know what "normal" is anymore.

Controversy over the safety of breast implants continues to be hotly debated by doctors, patients, and implant manufacturers. For now, silicone implants are banned—some diseases have been linked to silicone leakage and there's just not enough long-term data available to prove they're safe. And the US Food and Drug Administration only approves saline implants for women 18 years and older, recognizing that adolescent bodies are essentially still "works in progress."

BUYER BEWARE

NEXT TIME YOU RUN OUT OF HORROR STORIES for a sleepover with your friends, try typing in the words "plastic surgery" and "botched" on your favorite Internet search engine and see what comes up.

You can't believe everything you read on the Internet, but most people don't get rich by posting warning signs to others about the terrible mistakes they made in trying to improve their appearance. This is in stark contrast to the many Web sites promoting plastic surgery and breast implants in which the owners of the Web sites *do* stand to get wealthy if you believe their promises. A healthy degree of skepticism comes in handy.

But if many plastic surgery procedures are potentially dangerous, how come most of the stories you see on TV or in fashion magazines make them sound like they're no big deal?

The short answer is that plastic surgeons and cosmetics companies spend a lot of money advertising their services and products, and magazines and television stations depend on those advertising dollars. Sources of information that are designed more to entertain (fashion magazines or lifestyle shows) than inform (serious newspapers and news programs) are less likely to feature stories about what can go wrong. And some entertainment media rely on the information provided to them by plastic surgeons, who benefit by emphasizing only the good news stories.

Keep in mind, too, that for the most part, people who get plastic surgery don't want everyone to know they've had it done. So when the procedure leads to problems or threatens their health, they're sometimes too ashamed or embarrassed to complain—especially if they've paid a whack of money.

In fact, a study of Canadian women with breast implants in 2003 found that 40 percent wanted them removed. The study didn't explore their reasons, but some plastic surgeons point out that if patients are hoping the implants will solve a bunch of

personal problems, they're often disappointed after surgery when their lives don't radically change for the better.

BULKING UP

ARE YOU STARTING TO GET THE IMPRESSION that it's mostly women and girls who are crazy enough to seriously endanger their health for beauty reasons? Not so fast... These days, more and more guys are engaging in equally risky behavior in the hopes of being seen as more desirable.

Long before Arnold Schwarzenegger made the Terminator a household name, the masculine ideal tended to be athletic and "built." But until recently, advertisers didn't often show really buff male models clad only in briefs. So guys today are much more conscious of whether or not they live up to the ideal than ever before.

The pressure on guys to live up to an ideal body image has increased enormously in recent years. Nearly naked male torsos are no longer seen only in a few specialized bodybuilding magazines; today, they are prominently featured in billboard ads for everything from cologne to jeans, and in an increasing number of fitness and lifestyle magazines for men.

Short guys wishing they were taller (because height is part of the "tall, dark, and handsome" equation) can't do much about the length of their legs; instead, they're sometimes inclined to build up their upper body muscles. Even taller teens who experience beanpole growth spurts that give them height but not weight believe their looks would be improved by adding some bulk. Working out at the gym can help, but it's often a long, slow process. Some turn to protein shakes and other dietary supplements in an

effort to counter their scrawni-
ness and get bigger, faster.

Other guys go one step fur-
ther and buy anabolic steroids,
which are drugs made from high
doses of the male hormone
testosterone. Many of these
drugs have proven to be effec-
tive; with a weight-training pro-
gram, they can make a difference
to an athlete's size, strength, and
speed. And the incentives to use them go beyond looking good.

ROID RAGE

Steroid-users aren't usually looking for a personality
makeover but the drugs can sometimes wreak as much
emotional damage as they do physical. Extreme mood
swings are common, and guys can experience "roid rage,"
which makes them act violently even though they would
never behave that way without the steroids. ("Roid rage"
has actually been linked to several murders.)

In competitive sports—from boxing and baseball to track and
field—the rewards for winning are often enormous. What athlete
wouldn't like to be the first draft pick, or boast an Olympic medal?

The problem is, in addition to being illegal in sports, anabolic
steroids deliver a lot more than muscles. The bulkier physique
can be accompanied by a range of side effects, including bald-
ness, breast development, severe acne, stunted growth, kidney
damage, heart attack, liver cancer, and shortened life expectancy.

Ironically, it doesn't sound like the average steroid user is likely
to improve his chances in the beauty contest of life.

Until a few years ago, guys were usually the only ones abusing
steroids. But now some girls and young women are also attempt-
ing to build a more muscular physique through drug use. They
face the same kinds of health risks as the boys, plus the possibil-
ity of developing permanent facial hair.

IMAGE REFLECTIONS

SHORT-TERM PAIN FOR LONG-TERM GAIN can be considered a
good deal when it comes to beauty. Getting an ear pierced, for
instance, hurts for all of two seconds, and gives you the oppor-

tunity to creatively decorate your earlobe for the rest of your life.

But short-term gain for long-term health risks is another matter entirely. Nobody wants indulging their vanity today to translate into ongoing suffering 10 or 20 years from now. The trick is in figuring out which fashion choices or procedures are likely to have health or comfort consequences down the road.

There's no simple way of predicting. But here are a few questions you might consider when weighing the pros and cons of future "self-improvement projects." Whether you're contemplating anti-cellulite cream, hair dye, protein supplements, surgery, or a tattoo, ask yourself:

* Are the impacts of this procedure temporary or permanent?
* If they're permanent, can I see myself being happy with this fashion statement 25 years from now?
* What risks are involved, and are they worth it?
* Is it possible that the treatment or procedure will actually make me look worse?
* Is it really safe? Who says so, and do they make money if I believe them?
* Are there other sources of information about this treatment that are independent and trustworthy?
* Is the evidence of the procedure's safety based on just a few examples, or have independent experts conducted long-term studies?
* How long has this particular process been around? How do people who had it done 10 or 20 years ago feel about it now? If it's still at an experimental stage, how do I feel about being a guinea pig?
* Are my expectations for how this change will affect my life realistic? Am I hoping that a cosmetic process will also alter my personality or make me more popular overnight?

CHAPTER

5

DOUBLE STANDARD

Clock the time spent by the average 15-year-old guy getting ready to head out the door in the morning, and it might be all of 15 minutes: shower, maybe apply a bit of hair gel, climb into some jeans and a T-shirt, and he's done.

Then measure that against the time a typical 15-year-old girl might spend—it will probably add up to double, triple, or even quadruple the investment. On top of the shower, she's likely to blow-dry and/or straighten her hair, apply makeup, and ponder each component of her wardrobe. Even if she ends up wearing jeans and T-shirt, it's likely she'll more carefully consider *which* jeans, and *which* T-shirt.

Why is that, exactly?

Some people chalk it up to female vanity; they claim women are biologically programmed to spend a lot more time gazing at themselves in the mirror.

But read on: the truth is quite a bit more complicated than that.

> "Men are much freer. I like how when they leave for the evening, they never have to take anything with them. When they get a pimple it's like, "Yeah, I have a pimple, deal with it."
>
> —actor Drew Barrymore

THE SO-CALLED "FAIR SEX"

CHECK OUT ALL THE WORDS we have to describe really attractive human beings and you'll notice that many of them are rarely applied to men. Guys can be cute or handsome, depending on their age and size, but try calling one beautiful, lovely, pretty, graceful, exquisite, delicate, stunning, or ravishing.

You might think that women and girls have always been considered the "fairer" sex.

You'd be wrong.

The early Greeks paid special attention to the male form, believing men to be more beautiful than women. As a result, their art celebrated the ideal male physique and the Olympics were established in part as a tribute to the athletic feats that men were capable of performing. In contrast to the way the world operates today, women in ancient Greece were more of a sideshow than the main event.

Although the balance then shifted to a greater focus on female beauty, throughout history rich guys and noblemen have typically lavished a lot of attention on their appearances, being able to afford luxurious fabrics and good tailors. For instance, you've probably seen pictures of the 16th-century British monarch Henry the VIII (the one who went through six wives). He's always depicted wearing elaborately embroidered jackets with enormous puffed sleeves that make him look like the original Hulk.

Then, for a few decades or so during the 18th century, "dandyism" flourished. This allowed fashionable young British and European men to go overboard, wearing decorated velvet jackets, fine silk stockings with frilly garters, jeweled shoes, and

ornate gloves, not to mention calf, thigh, and crotch padding (I'm not making this up).

But look around you and you'll have to agree: it's been more or less downhill for guys on the fancy fashion front ever since. In contrast to women's clothing, most men's wear today tends to downplay the male physique and help guys melt into the background, wearing the expected business suit, chinos, or jeans, depending on who they are and what they do.

Some people blame the industrial revolution. During the 18th century, as manufacturing and transportation technology developed, people became very focused on productivity, and it was thought that men's appearances should reflect their usefulness— show them to be serious and effective at work, as opposed to beautiful and elegant. Dark-colored suits became a sort of "uniform" and, compared to women's wear, they haven't changed a whole lot since.

But before you start feeling sorry for guys, who were more or less abandoned by the beauty police a century or so ago, there are advantages to not being prized for the fashionable details of your hair, clothing, and all-around physical presentation. For starters, you save hours and hours each week, and you don't get judged nearly so often or so harshly on the basis of how you look.

Once upon a time, guys really got to dress up: the foppish styles of 18th-century "dandies" included velvet jackets, frilly garters, and crotch padding.

WOMEN'S WORK?

"DANDYISM" AND THE ANCIENT GREEKS ASIDE, all sorts of writers and philosophers have weighed in on the subject of personal beautification rituals, and by and large they've agreed: it's women's work.

Helena Rubenstein, founder of a major cosmetic empire, summed up the attitude of many who preceded her when she said:

There are no ugly women, only lazy ones.

... suggesting that women could all be more beautiful with a bit of effort. This may be true, but saying so also served her self-interest: if people believed her claim, they might be more likely to run out and buy her products.

Primping tools: his.

Primping tools: hers.

Here's Looking at You

Try this experiment: Flip through any fashion magazine and check out the advertisements or fashion spreads. Chances are most of them will feature women. Stop for a moment and try to imagine the photographer taking the pictures. Do you envision a woman or a man behind the camera?

British art historian and writer John Berger made a TV series about the difference between the way artists and advertisers typically represent women, and the way they usually portray men. Called "Ways of Seeing," the series showed how much of our cultural imagery has reinforced the idea that *"men act* and *women appear."*

Using many examples from a variety of places and times, Berger demonstrated that men are more often shown *doing* something, while women are more often pictured simply *posing* for a male audience. Others refer to this as the "male gaze," by which they mean that there's something about the way we paint or photograph women that often seems to assume the viewer of the image is male.

Being portrayed so often as objects to be looked at—as opposed to people who are doing things—makes women and girls much more aware of themselves as being watched. In the process, they absorb the message that they're being evaluated on the basis of how they look.

And the message is more pervasive today than ever. From music videos to billboard advertising, from popular sitcoms to consumer magazines, the lesson is inescapable: real women make an effort to look their best; they put on makeup, they fuss over their hair, they wear fashionable clothes—and above all, they worry about being the right size and shape.

Real vs. Ideal: Messing with Body Image

Maybe it's the amount of junk food we eat; maybe it's the size of the steaks we consume; or maybe that frequently advertised cereal really *is* "the breakfast of champions"! Whatever the cause, North Americans are a lot taller and heavier today than we were a couple of generations ago.

WEIGHTY MAGAZINE MESSAGES

Go figure: even though more men than women are overweight, women's magazines emphasize weight loss and body image almost 10 times as often as magazines targeted to guys.

The women's mags imply that losing 10 pounds or having a buffer bod will lead to greater happiness. Even though there's no evidence to support this belief, 15 percent of women surveyed in 1997 said they'd be willing to sacrifice five years of their life if they could be their ideal weight!

Men's magazines are more likely to suggest that the way to improve your life is to expand your knowledge or take up new hobbies.

Unfortunately, the "ideal" image of femininity—as seen on TV, in beauty pageants, and in magazines—has become physically *smaller*. When real women and girls today compare themselves to female sitcom stars, beauty contestants, or models, they're looking at bodies that aren't remotely representative of the average population. These ideal women are actually much skinnier than is healthy and—because when you lose weight, you lose it all over—many of them have had breast implants in order to compensate.

POWER PLAY

WHEN CRITICS SLAM THE MEDIA for putting so much emphasis on women's appearances, some people respond by suggesting that if beautiful young women didn't agree to appear in the advertisements that reinforce such messages, the problem would be solved. "It's women's own fault," they argue. "And if women stopped buying fashion mags and makeup, then the magazines and cosmetics companies would go out of business."

These people may have a point. But it's not so easy to turn around centuries of emphasis on women's looks overnight. Our attitudes about what's feminine and what's masculine—in terms of appearance and behavior and jobs and responsibilities—are quite entrenched.

Partly it's a power issue. For centuries, women in many societies were treated extremely unfairly. They weren't allowed to go to school or decide when or if they wanted to marry. They had very little control over much of their lives, and were expected to do what their fathers or husbands told them to. Their primary value was defined by their ability to attract and serve their husbands.

Although many cultures depended on women's work, extraordinary emphasis was still also placed on whether or not they lived up to the current beauty ideal. And often the ones who did had power as a result. They were sometimes able to exercise more independence and choose whom they would marry.

This is still the case today, of course, because we still prize beauty, and beautiful women are very desirable to men. But what's different in the 21st century is that—in the Western world, at least—women and girls have many more choices, and are valued for their intelligence and strength, as well as their beauty.

Education and work opportunities allow women to be financially independent of men. They might still care about their appearance, but it's no longer the only—or even most important—source of their power.

Casting Couch Woes

Yet even today, the power that comes from being beautiful can be a double-edged sword. On the one hand, it can get you noticed; on the other hand, the kind of attention it generates can often be difficult to handle. Being whistled at on the street can make a girl feel good about how she looks, but it can also make her feel vulnerable and threatened.

Judy Holliday, a famed Hollywood actor of the 1940s, was reportedly chased around an office by a big movie producer, who wanted to "appreciate" her beauty in a physical, as opposed to purely visual, way. Finally, Ms. Holliday stopped running around the desk and simply pulled her falsies (pads inserted in her bra to make her breasts look larger) out of her blouse. She handed them to the producer, saying, "Here, I think this is what you want."

Unwanted advances continue to be a problem to this day. Actor Jenny McCarthy has also experienced both sides of the sword. She got her first show business break by posing nude in a men's magazine. But then, after establishing herself as an actor and comedian, she found she had to constantly battle the assumption that, having strutted her stuff to get attention once, she would do so every time she was asked. Often at auditions, she has said, the directors "would tell me to stand up and take my clothes off. These are high people in the industry... They would say things like, 'You have to have dinner with me in order to make it in this town.'"

This kind of sexual harassment may be less common today, but a female star's nudity still

NEVER MIND ME — CHECK OUT MY DATE!

Elle magazine recently surveyed 59,000 of its male and female readers on the subject of body image. When asked which they would rather have, a perfect body themselves, or a mate with a perfect body, the vast majority of the women chose a perfect body for themselves.

In contrast, the guys were less interested in their own perfection and more interested in having mates whose bodies were perfect.

generates much more buzz for a film than her male co-star's, and there are many, many more magazines catering to guys' interest in looking at images of beautiful women than there are magazines featuring pictures of good-looking guys. Consider, too, that the few jobs in which women consistently get paid more than men include modeling and stripping.

TALL, DARK, AND HANDSOME

THIS IS NOT TO SAY that we haven't always had beauty standards for guys, too. The expression "tall, dark, and handsome" wasn't coined to refer to horses.

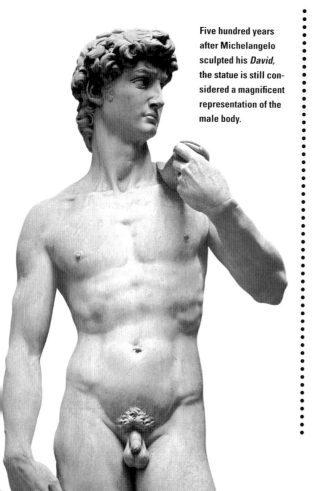

Five hundred years after Michelangelo sculpted his *David*, the statue is still considered a magnificent representation of the male body.

Like women, guys with clear skin, thick hair, and toned muscles have typically been preferred over those without. But a few scars here and there—even the kind earned in a knife fight, or getting hit by a rock—have always been much more acceptable on a man than on a woman. Maybe that's because the scars say, "This guy confronted danger and survived!"

Other characteristics deemed handsome in men that are not desirable in women include strong muscular jaws, lean rectangular faces, and piercing eyes.

But throughout the ages, boys and men have also been valued more for other things besides their physical appearance. Their earning power, for

instance; their ability to feed their families and put a roof over their heads. Guys with power—whether it came from having land, or money, or followers—have typically looked like good mates, regardless of how physically attractive they were.

Even today, guys who would never be mistaken for a movie star or model are judged to be very desirable if they have other qualities. Power and authority have assisted many ordinary-looking men in being perceived as attractive. And talented male actors or musicians are often seen as sexy, even though without their talent and the power and attention it gets them, they might not make anyone's top 10 list.

> Women will never be equal to men until they can walk down the street with a bald head and a beer gut and still think they are sexy.
>
> —popular joke

So guys may not have to worry as much about whether or not their face and body conform to that of a single male ideal. But the power issue puts a different kind of pressure on them. The kind of job they have and the kinds of things they own can influence whether people judge them to be winners.

SAYS WHO?

YOU DON'T HAVE TO KNOW THE HISTORY behind the double standard of looking good or be out in the workforce to have experienced it. By high school, the effects are already being felt. Here's how a bunch of 17-year-old guys see the differences among their peers:

* Guys want to look bigger, whereas girls want to look smaller. So we work out and they diet.

* Girls worry way more about their outfits, get stressed about what they wear.

* Every pretty girl at our school I can think of has done something to her hair.

* I know some girls who won't date any guys who are under six feet tall.

* Most girls are more forgiving of guys' looks than guys are of theirs. Other things are more important to them.

* If you're approachable, girls will like you.

* They feel the need to be in a relationship more than guys, so they're not as picky.

* Guys get teased if they go to a tanning salon.

* You get known as a pretty boy if you're excessively focused on your looks.

* It's okay for girls to admit they spend time on their looks, but it's not cool for guys—we're supposed to look natural.

Girls' perspectives tend to reinforce the guys' views:

* We want guys to be slim, toned, but not really built.

* Height is nice—or at least a guy who projects tallness. If he has confidence, that helps.

* Skater hair—long and shaggy, like layered—I like that. You want it to look good without looking like they've tried to make it look good.

* I like guys with amazing eyes that really look at you.

* I want them to accept me for who I am.

* Personality is more important than looks.

* I like to look at guys with amazing bodies, but often I can't stand those kinds of guys when I get to know them.

* It's really important for girls to be good-looking.

* I berate myself after eating certain foods, and I skip meals. I would be happier if I was thinner.

* I always feel I could look better than I do.

Both sexes agree that the challenge for guys is to look good without appearing to spend any time working at it.

OLD FARTS AND SWEET YOUNG THINGS

ANOTHER PLACE YOU SEE THE DOUBLE STANDARD operating is at the movies. You may have noticed this: there's a long history of pairing up aging geezers with young female stars.

If you were an alien hacking into some earthling's satellite dish in search of entertainment, Hollywood movies might lead you to conclude that women rarely live past the age of 35. Meanwhile, guys remain active well into their 60s.

Craggy-faced, balding, and out-of-shape guys like Jack Nicholson and Nick Nolte are often paired up with female co-stars like Helen Hunt and Julia Roberts, who are young enough to be their daughters.

In show business, women have to work a lot harder to stay young-looking, while guys are like fine wine: the older they get, the better they are. On top of that, the real-life consequences

SEARCHING FOR REAL WOMEN

In 2003, dozens of famous female actors participated in a documentary film about aging in their industry called *Searching for Debra Winger.* The title of the movie refers to one of the best-paid female stars of the 1980s who retired at the age of 39 rather than fight the beauty battle that faces all women in Hollywood.

Female characters typically make up only about a third of all roles in American movies, and the vast majority are for women under the age of 40.

In the documentary, actor Martha Plimpton comments, "At least for men there are options. There are character roles. There are guys doing some great work who have a face like a foot. There ain't no ugly women. There aren't even any regular women."

When Twiggy became *the* fashion model of the 1960s, she was described as looking about 12 years old. Her childlike appearance was a radical shift from previous beauty ideals.

of not staving off the wrinkles and gray hair that accompany growing older are more serious for women. Although there are a few exceptions (Katherine Hepburn remained a star through four decades), the earning potential of female actors, models, and news anchors has a tendency to plummet the minute they start looking like they've hit middle age.

But off-screen celebrity romances have started to challenge the idea that older women have passed their best-before date. Stars like Drew Barrymore and Madonna have dated or married younger guys. Even so, the tabloids make a big deal out of such relationships. Newspaper and magazine writers that didn't bat an eye over Harrison Ford dating Calista Flockhart suddenly printed three-inch headlines about 40-year-old Demi Moore and her much younger boyfriend, Ashton Kutcher.

BEEFCAKE JOINS CHEESECAKE

HERE'S ANOTHER RELATIVELY NEW TREND: until recently, naked men in advertising were as scarce as plain women on TV. And nobody had even heard of the term "six-pack" to describe a set of abdominal muscles.

Not anymore. Since the 1990s, all sorts of advertisers have jumped on the "Let's exploit men, too!" bandwagon and started using beefcake ads to attract consumer attention. Suddenly everywhere you turn, some billboard or magazine ad is featuring bare-chested male models flashing the kind of muscle-bound physiques that most guys can only dream of having.

In addition to featuring buff male bodies, the ads are also encouraging women to ogle them. Coca-Cola created a classic example of this: one of its TV commercials featured a good-looking construction worker stripping off his shirt while being drooled over by a bunch of female office workers.

With increased media focus on super-defined male muscles, the double standard may be on its way out. But the only people likely to benefit are the ones making and selling ab-crunch machines and protein supplements.

Some men object to this kind of strategy. They're beginning to realize the downside to being compared all the time to ideal images of human perfection—ones that are as difficult and dangerous for men to achieve as they are for women.

Guys aren't as physically vulnerable as women and girls, and don't usually worry that a display of their sex appeal might be seen as an excuse for someone to sexually assault them. But being encouraged to feel insecure about how they measure up physically has consequences: they worry more today than they used to about their bodies; they spend more time

THE PRINCE'S SURPRISING CHOICE

Years before the death of Princess Diana, she suffered another fate that's not supposed to happen to beautiful women. Her husband, Prince Charles, made it clear that, as young and lovely as she was, he actually preferred another woman.

As it turned out, the Prince's true love, Camilla Parker-Bowles, was much older than Princess Di. Camilla's face bore the wrinkles of a middle-aged woman, her hair was not immaculately coiffed, and the shape of her body didn't betray an eating disorder or addiction to the gym. But Charles was clearly in love with her, and not his wife, despite all the attention Diana invested in—and received for—her fashion-model-style good looks.

and money trying to sculpt themselves into the desirable shape; and some engage in risky behavior in pursuit of the media-dictated ideal.

What prompted advertisers to start featuring gorgeous male bodies in the ways that they used to use only female bodies?

In a word, money. It has everything to do with wanting to sell more products. Marketing executives figured that if advertising has convinced women to buy stuff they may not need for more than 150 years, the same approach could work with guys.

The strategy has paid off. In the past few years, men's spending—of time and money—on personal care products like skin cream and hair gel has grown by leaps and bounds. Faced with impossibly buff images of "ripped" male bodies with no chest hair, more and more boys and men have started to be disappointed by their reflection in the mirror. As a result, sales of hair removal treatments, exercise equipment, and diet supplements have soared.

IMAGE REFLECTIONS

MAYBE THE DOUBLE STANDARD IS ON ITS WAY OUT. What do you think? Are women and girls starting to expect guys to live up to the kind of perfection that they feel guys expect of them? And if so, is this good news?

Some people fantasize about eliminating not just the double

standard, but *all* standards that are based on something other than reality. Then the pressure would be off both sexes.

In the age of saturation advertising, it's hard to imagine. Whether we're talking bodybuilder pecs promoting beer, or scrawny thighs flogging anti-cellulite cream, images everywhere seem deliberately designed to distort our perceptions of human ideals in order to sell us a whack of products. It seems likely that as long as there's money to be made off people's personal insecurities by planting the seeds of doubt and then offering a store-bought solution, there will be companies lining up to try to persuade us, whether we're male or female.

Which is all the more reason to do a reality check every time you're confronted with some claim

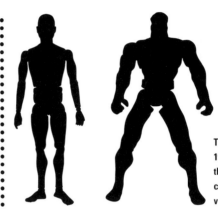

The realistically sized 1960s action figure on the left looks puny compared to today's version on the right.

EXTREME HEROES

Disney cartoon heroines aren't the only ones to have become less and less realistic over the past 50 years. Over the same period of time, male cartoon and video game characters have also become distorted.

When the G.I. Joe action figure doll first came out in 1964, he looked like a fit but reasonably normal guy. Thirty years later, he's morphed into a freak show at the circus.

The biceps of "GI Joe Extreme," released in 1998, are bigger than the doll's waist! If they were ratcheted up to human scale, they'd be even larger than the arms of the most massive bodybuilders. And video game action heroes like Duke Nukem are continuing the trend.

about what's macho or feminine, hot or cool. Just to get you started, consider:

* Most of the promises advertisers make are about as guaranteed as a summer snowfall in Los Angeles.

* Women and girls have way more choices today than ever before. This means more opportunity to make decisions—on the beauty front or elsewhere—that are right for you, no matter what anybody else is doing.

* Regardless of what advertisers say or imply, personality plays a big role in determining a person's attractiveness; girls may be more conscious of this, but guys are also affected.

* If men can be considered good-looking with silver hair and lined faces, why can't women?

* G.I. Joe and other animated action heroes are probably on steroids.

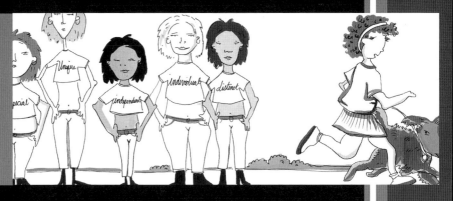

BEAUTY POWER

If you ever doubted the power that beauty packs, just notice the way we describe gorgeous people—as if they had the wizardry of Harry Potter:

We refer to those we judge to be extraordinarily good-looking as "stunning"—as if merely looking at them can knock us over and render us speechless. We say they are "bewitching"—as if their beauty embodies magical powers that we can't explain and are helpless to resist. We call them "ravishing"—as if their physical appearance were capable of carrying us off by force.

In other words, we attribute all sorts of power to people just because of how their faces are arranged and their bodies are put together.

Sometimes attributed power translates into real power. And the truth is, human beings have used beauty in order to exercise power over others throughout history. Hotties of their day have often taken advantage of the fact that their looks have made it easier for them to get what they want.

On a larger scale, groups of people have also used the power of beauty—as *they* defined it—to advance their interests at the expense of others. Sometimes this has been unconscious, and sometimes deliberate.

BATTLES ON THE BEAUTY FRONT

FOR INSTANCE, people of different races have tended to celebrate as beautiful the things that set their physical appearance apart from others.

When Europeans first came to North America in the 15th and 16th centuries, they sought to conquer the original inhabitants and claim the land as their own. In the process, they denigrated Native people as less civilized and pointed to their darker-colored skin (among other things) to justify this claim. Ever since, the dominant images of "beautiful" people on this continent have tended to be fair-skinned Caucasians.

Although the percentage of people of color in many large North American cities is now close to 50 percent, flip through mainstream consumer magazines or national TV networks and you can't help noticing that the models and actors featured most often in popular media are overwhelmingly white.

In addition, the African, Asian, Hispanic, and Native American faces most likely to be portrayed in the media as beautiful have tended to be those who most resembled white people—either because of the lightness of their complexion or the shape of their facial features. Halle Berry,

THE MEAN SPIRIT OF THE LAW

Chicago city bylaws once imposed fines on people who were considered unsightly by those in power. From 1966 to 1974, a subsection of the vagrancy law dictated that people who were "diseased, maimed, mutilated, or in any way deformed so as to be an unsightly or disgusting object" could be fined for appearing in public.

The attitudes that led to the creation of such laws are shocking today. Now we use the legal system to *protect* people with disabilities from discrimination and ensure they're full participants in every aspect of society.

THE PROVINCE · Wednesday, May 2, 2001 **B5**

U.S. TV still white man's world, study says

By Lynn Elber

LOS ANGELES — More than a year after the major U.S. TV networks agreed to better reflect the country's ethnic mix, broadcasters continue to marginalize minorities and women, according to a new study.

Overall, network television remains a white man's world, the advocacy group Children Now concludes in its study of ABC, CBS, NBC, Fox, UPN and WB. The group conducted a similar study of the 1999-2000 TV season.

The prime-time sitcoms most likely to draw younger viewers offer the least diversity on TV, says the report released yesterday. A viewer watching TV on any given night during the 2000-01 season would most likely see featured "a thirty-something, white male" working in a professional job, the study said.

The vast majority of the character's friends and co-workers also would be white professional men. Minorities appear mostly to provide "a service, a piece of information or a punch line," the study said.

Most of the networks, except CBS, refused comment. "We believe that CBS has made tremendous strides to increase its diversity on screen, behind the camera and in the executive suites," network spokesman Chris Ender said. "However, we certainly recognize that more can be done and more will be done."

Situation comedies, the most-popular genre among children, are the least diverse programs on TV, the study said. Only 14 per cent have ethnically mixed casts, while the vast majority tend to feature all-white or, in a few cases, all-black characters.

In comparison, mixed leading casts are featured on two-thirds (67 per cent) of programs, mostly dramas, airing during the 10 p.m. PDT hour. That's when the fewest children are watching, the study says.

The study questioned the message segregated sitcoms are sending young viewers, noting that a 1999 Children Now poll found 12- to 17-year-olds chose comedians as their top TV role models.

While the number of black characters in network series increased to 17 per cent from 13 per cent, Hispanics dropped from three per cent to two per cent, Asian Pacific American characters increased from two per cent to three per cent.

By comparison, blacks and Hispanics each make up about 12 per cent of the U.S. population and Asian Pacific Americans are nine per cent, according to 2000 census figures.

Women aren't faring well on television either. There are twice as many male as female characters and the women tend to be cookie-cutter "beautiful, young, thin and white" and motivated mostly by looks and love, researchers said.

Although white actors, models, and news-makers still seem to get a disproportionate amount of ink and camera time in North American media, practices are slowly changing to better reflect society, which is becoming more diverse all the time.

- with her coffee-colored skin, and Lil' Kim, whose nose has been made smaller through surgery, are examples of this subtle prejudice in action.

But it's beginning to change. North American popular culture is starting to broaden its definition of what's attractive to reflect the diversity of people who live here. Fashion magazines, television shows, and movies are increasingly featuring Asian models and African-American film stars. Hispanic performers like Jennifer Lopez and Jessica Alba have also helped to send the message that beauty has many different faces, and not all of them are white. And as the picture of beauty changes, attitudes shift along with it.

Extreme Makeovers

Defining pale skin as desirable wasn't the only beauty measure that was influenced by early racist and anti-Semitic attitudes in North America. The shape of one's nose became another important beauty indicator. As a result, some immigrants experienced all sorts of mistreatment based on ignorant assumptions and stereotypes.

Unable to change attitudes or society, some resorted to changing their appearances. They sought nose jobs in an effort to pass as WASP, to be accepted by the people with power in North American society.

ALL HAIL MISS... WASP?

The acronym WASP is short for "White, Anglo-Saxon Protestant." In North America today, it's often used in a derogatory way to dismiss someone as being conservative and unfairly privileged. And historically, people of WASP background, whose ancestors came from northern Europe, have had more money, power, and influence here than people who came from other parts of the world.

Their control of business and the media meant they got to decide all sorts of things, including who could be called beautiful.

When beauty pageants were first created in North America in the late 19th century, only white women were allowed to enter. In 1945, when the Miss America pageant was won by Bess Myerson, there was a big uproar. Although she was white, she was Jewish, and therefore not a "WASP."

But Bess Myerson used the attention that winning the pageant gave her to challenge bigotry. "You can't be beautiful and hate," she said.

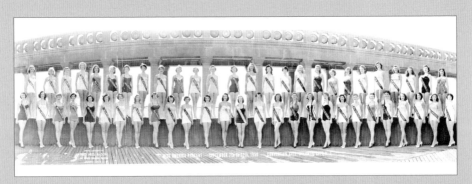

In 1953, contestants for the Miss America crown were still over-whelmingly white. It wasn't until 30 years later that Vanessa Williams became the first black woman to win the title.

Similarly, after World War II, when discrimination against the Japanese was at an all-time high, many Asian Americans sought surgery to alter their eyes to make them look more Western. These days, because American popular culture is exported all over the planet, and Caucasion models and movie stars are as famous in

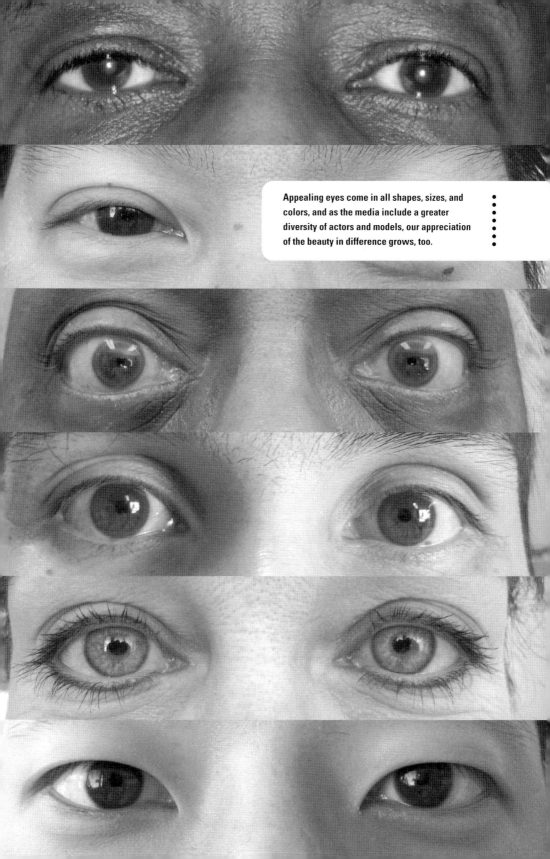

Appealing eyes come in all shapes, sizes, and colors, and as the media include a greater diversity of actors and models, our appreciation of the beauty in difference grows, too.

Beauty and Success!
Both May be Yours ~ So Easily
There's No Excuse for Not Having Them

From Cabin to Mansion
~ from Slave to Society Leader
~ from Poverty to The Greatest Benefactress of Her Race

You, Too Can Enjoy
a Lovely Complexion

Beautiful Hair ~
a Woman's Crowning Glory

Even though the dominant images of beauty in the early 1900s were unmistakably white, Madame C.J. Walker created and began marketing a line of cosmetics for black women in 1905. In the process, she became America's first African-American female millionaire business-owner.

● ●

Asia as they are here, Western-style eyes continue to be seen by some Asians as markers of beauty.

Cosmetic surgery couldn't help African Americans avoid discrimination, but that didn't mean there weren't other people looking for ways to make money by encouraging them to come as close to the prevailing "white" beauty standard as possible. Some companies developed concoctions called "Wonderful Face Bleach" and "Imperial Whitener" that claimed to lighten skin; others invented hot irons and creams designed to straighten curly hair.

Decades later, some of these products are still big sellers, with hair straighteners especially flying off store shelves. Today, straight hair has become so much the norm in fashion media that people accept its dominance as simply a style choice, not seeing it as a means of valuing the look of one ethnicity over others.

SIZE BIAS

ONE FORM OF BEAUTY DISCRIMINATION that affects all races is based on weight.

In the movie *Shallow Hal,* Gwyneth Paltrow's character is so fat she can empty a swimming pool of water with a single cannonball. People are completely repulsed by her because of her obesity, and the story makes it clear that the only reason Hal falls in love with her is because he can't actually see her physical appearance as it really is.

The film plays on one of North America's ultimate beauty biases: packing too many pounds disqualifies you from being considered good-looking.

This translates into a lack of power. Studies have shown that, in addition to being judged unattractive, people who are perceived as being fat are also much less likely to be hired, promoted, or paid a competitive salary. And although there are laws that prevent discrimination against people on the basis of their race, religion, gender, or age, no such laws exist to protect the overweight, except in the state of Michigan.

The fear of becoming fat drives some people to extreme and dangerous behavior. Eating disorders are a prime example. Many girls and women become desperate to achieve the media's unrealistic body image ideals and end up starving themselves, going overboard with exercise, or purging their bodies of food through laxatives or vomiting.

Media images and social pressures on girls to be slender certainly enourage anorexia and bulimia, but they're not entirely to blame. Often long-term emotional problems stemming from troubled family situations or sexual assault are also a factor. And many girls who develop eating disorders have low self-esteem and feel that they have little or no impact on other people or events in their lives; controlling their food intake or body shape becomes a way of exercising power.

The "power" that women and girls gain through disordered eating is a complete illusion. Instead, the conditions seriously

BEAUTY CRIMES

If white beauty ideals can make racialized people feel badly about their looks, attempts to change those looks can sometimes threaten their lives.

A Vietnamese woman died while undergoing plastic surgery to alter her appearance to look more Western. The person performing the operations was not a doctor at all, but a hairdresser trying to make more money. Police closed down her unlicensed Toronto clinic and warned the public that there are many other illegal practitioners who advertise in foreign-language newspapers, preying on Asian women who want to fit more easily into North American society.

Actress Tracey Gold, a child star on the 1980s TV series *Growing Pains,* recalls that one rude comment from a casting director about her body triggered her initial bout with anorexia when she was 12. Then at the age of 16, the producers of *Growing Pains* noticed she'd gained a few pounds and told her she'd have to go on a diet. She stopped eating entirely during the week, began binging on weekends, and ended up in the hospital with heart palpitations.

More tragically, 1970s singer Karen Carpenter started dieting after a newspaper article described her as "chubby." Her fame brought the problem of anorexia into public awareness and she eventually died after a painful battle with the disorder.

weaken them; their self-perceptions become so severely distorted that their controlling behavior ends up threatening their health with a host of physical side effects:

DISORDERED EATING BITES

Anorexia

- loss of menstrual periods
- weakness
- osteoporosis or bone damage
- hair loss, pigment changes
- vitamin and mineral deficiencies
- stunted growth
- starvation and death

Bulimia

- gastrointestinal damage
- iron and other nutritional deficiencies
- diarrhea
- kidney damage
- damage to teeth, mouth, esophagus
- heart attack

Guys are affected by eating disorders, too, although not nearly as often; they're generally more satisfied with their bodies than girls. But many teen and college-age guys wish they were heavier and more muscular, and seek power through working out and developing a ripped physique.

Singer Karen Carpenter's death from heart failure caused by anorexia in 1983, at the age of 32, was many people's introduction to the previously little-known disease.

BRANDED BEAUTY

IF SOME PEOPLE risk their health through attempts to control their bodies, many others risk their finances through efforts to win at the wardrobe game. More than anyone else, teenagers suffer from the brand-name beauty disease in which certain clothing manufacturers become essential weapons in the beauty power wars.

Whether it's Parasuco in Montreal, American Eagle in the midwest, or Tommy Hilfiger in California, often what matters in clothing is not the color or the shape, but the name—and the more visible it is, the better. More so than ever before, brands have become a means of saying: "We're beautiful, rich, and important"—and at the same time implying: "If you're not dressed like us, *you're not!*"

Buying the right brand is like having a membership in the "in" crowd, like silently informing everyone around you that you're savvy enough to know what's hot. The chosen brand embodies the irresistable promise of automatic cool to anyone who has the bucks to buy it.

But what about those who *don't* have the bucks?

> I was shopping one day and I saw this scarf that was so ugly. But then I noticed the brand name and it became instantly more appealing.
>
> —Elizabeth, 13

The pressure to buy the right brand names is so harsh that many kids whose families can't afford them feel compelled to get part-time jobs just so they can dress well around other kids. They trade time to hang out with their friends for the money necessary to have the right clothes to hang out *in*.

Of course, the real power in this beauty equation is held by the brand makers themselves. They're the ones who get rich as a result. Consider the range in price for a pair of blue jeans. The cost of the denim material, thread, and zipper or buttons is often the same, whether the jeans are made by a high-end fashion designer or the local discount chain. But you can pay less than $35 for a no-name brand, or ten times that price—as much as $350—to advertise the Versace name across your tush.

Blue jeans are one of the most popular clothing items among North American teens, with the shopping dilemma being not if, but how many and which kind: high-end designer, no-name discount, or something in between?

> I feel like I'm wasting my money when I buy expensive stuff. I know that if you wear the right brands, people assume you're cool, but sometimes I don't care if I'm popular. —Megan, 13

Teen Trend or Adult Manipulation?

It seems contradictory, but even as brands have become the means by which many teens assess each other, the marketing campaigns that promote brands are sometimes met with suspicion. A British marketing firm that advises companies targeting kids tells its clients:

Teens are skeptical about advertising, and even more skeptical about companies that try to look cool. "It's like your dad pretending to ride a skateboard," as one teen put it.

—First Impressions Marketing

So how do big companies tap into and exploit the fashion cycle?

Adult marketing executives go on what they call "cool hunts"—they hang out in malls, coffee bars, and video arcades and they dress and talk like teens in an effort to gather information about what's popular. In particular, they recruit trend-setting opinion-leading kids to be their eyes and ears in the marketplace, to give them feedback about how to make the companies' brands cooler, and to promote new products to their friends.

The kids themselves become "insiders" (as in "inside teen culture, and willing to dish on what's cool"), and serve as real-life product placement opportunities, wearing new clothes or showing off new electronics gadgets in the hopes of getting their friends to buy.

Why? They're flattered to be asked their opinions, to be considered experts about what teens like, even if what the adults are really after is a better handle on how to make more money for their companies. And they get to keep the products they display.

The Individual Copycat

Making the right style statement is a bit of a balancing act. You may want to fit in, to be seen as wearing the brands and styles that have been approved by your crowd. Then again, what you wear and do to your hair are expressions of your individuality—you don't exactly want to be a clone.

Half of the university students in a recent study had pierced a part of their body other than their earlobes, and 23 percent had tattoos. Their reasons were contradictory: some wanted to record personal milestones or express their individuality, while others sought a visible form of identification with friends.

When it comes to looking good, there's always been some tension between innovation and imitation. One person or group comes up with a trend that they hope will distinguish them. If it's distinctive, interesting, or beautiful enough, others admire it. But when they succeed in copying the trend and it gets adopted by many people, it loses its value and is no longer so cool. Then the trendsetters have to create a new look to re-establish the fact that they are, indeed, different. That look, too, gets copied, and the whole cycle begins all over again.

For instance, other than earlobes, piercing wasn't a very popular practice when punks in the 1970s began piercing their faces and bodies. Now it's become much more mainstream, and because

lots of people are doing it, it's not considered nearly as edgy or avant-garde anymore. The same cyclical process gets applied to everything from low-rise pants and chunky shoes to long straight hair and heavy eyeliner. What comes in will eventually go out. Whether it makes a comeback some day is anybody's guess.

For me, beauty is the celebration of uniqueness, not conformity.
—model and actor Isabella Rosellini

The Fashion Police

Does this sound familiar? The latest trends are spiked blue hair and short-cropped tops, neither of which you're dying to have. But then the school issues a notice prohibiting one, your mother forbids you to do the other, and the newly restricted fashions become suddenly desirable.

It's human nature to want something that's off-limits, and in days gone by the ruling elites in some countries actually passed laws designed to prevent the lower classes from wearing specific fabrics and styles. At one time, certain residents of Venice were forbidden to wear more than a single strand of pearls at any one time, and in Japan, elaborately decorated kimonos and fine silks were reserved for the nobility. In other places, authorities even tried to legislate who was allowed to wear wide skirts or high heels.

But the laws always bombed. The people who were prohibited from wearing the restricted clothing or jewelry would either disregard the restrictions completely or they'd come up with their own takes on the fashionable items.

CELEBRITY CHIC

When stars affiliate themselves with certain beauty products or fashion brands, all sorts of people are not only more likely to buy the brands, but to pay more money for them.

But it's worth asking: does Britney Spears use the drugstore shampoo that she endorses in ads for Clairol every time she washes her hair? Does Lil' Kim wear Old Navy when she's not being filmed for a TV commercial promoting the company's clothes?

IMAGE REFLECTIONS

ANOREXIC FASHION MODELS ASIDE, the definition of beauty—in clothing, in skin color, in hairstyle—is slowly becoming broader and more diverse. Even The Gap—long known for its uniform khakis and T-shirt look—has recently hired stars like Beyoncé and Madonna to promote a less cookie-cutter image.

But there's even better news for the brand-weary and those who just wish the beauty wars would go away: a bunch of Cornell University students participated in a recent study in which they were sent to a series of parties. Prevented from wearing their usual styles, they were forced to wear Barry Manilow T-shirts instead. (Don't worry if you've never heard of Barry Manilow; the point was that he's considered the king of anti-cool.)

Were the Cornell students embarrassed to be wearing the T-shirts? No doubt. Did the other party-goers diss them for their fashion faux pas? Not so much: fewer than a quarter of the people they came into contact with even noticed what they were wearing!

So this chapter's reflections are:

* Beauty may wield power, but it's hardly absolute.
* There's no one definition of cool anymore; increasing diversity means way more choice and lots of room for differing opinions.
* Enhancing your assets and downplaying your flaws doesn't have to mean erasing your individuality or buying into the mainstream look.
* Why bother paying extra for brand names unless you really love the clothes? Brand labels really just tell people how much you paid for what you're wearing.

OPPORTUNITY OR KNOCKS?

Where French folk wisdom says that when it comes to beauty, suffering is *not* optional, a German proverb claims that "Beauty is a good letter of introduction." In a world where first impressions count, it's hard not to believe that looking good smooths your way and makes your life easier.

In our culture, visuals rule. From television and movies to magazines and the Internet, we're used to getting information and entertainment in picture form. And much of our contact with other people—at the mall or movie theater or simply walking down the street—is so brief and superficial that the most lasting impression we're likely to have of them will be of how they look.

It certainly seems easier to get picked for the cheerleading squad or voted most likely to succeed in romance if your reflection in the mirror says "model material." Shopping for clothes or showing up in gym class in shorts and a tank top may be easier if you're fit as opposed to overweight.

Yet all sorts of people who aren't classically good-looking achieve great things in the world or live happy, personally rewarding lives. So what do we really know about the advantages of being beautiful?

PLEASING IMPRESSIONS

IF TWO GUYS WALK INTO A ROOM and one of them looks like Jude Law and the other looks like Fred, the man who lives down the street, it's common sense that the guy with the movie-star good looks will attract more immediate notice.

"Power dressing" has more than one advantage. Wearing a business suit is not only useful for climbing corporate ladders—research shows that it also increases a guy's attraction rating. Other studies have found that it's easier for tall men to achieve CEO status than it is for their shorter colleagues.

Some research backs this up. In one study, two women were placed by the side of the road beside cars with flat tires; drivers passing by were more likely to slow down and help the certifiable babe than her plain-Jane counterpart.

When it comes to romance, beauty genes are no guarantee that sparks will fly and you'll fall head over heels in love, of course, but they may increase the likelihood of someone you don't know asking you out to a movie, or responding, "Yes, I'd love to" when you invite them to a party.

The Confidence Quotient
But beyond the obvious advantages are some other not so

obvious ones. In addition to making a good impression because their faces or bodies are appealing, good-looking people are often more confident than the average person. Maybe this is because they don't feel awkward the way people who are self-conscious or unhappy about their looks sometimes do. Beautiful people—at least to the rest of us—seem to just naturally fit in, no effort required.

Studies show they're also more likely to feel that they have control over their lives; they see themselves choosing and directing what happens to them, as opposed to having to respond to situations and people around them. But it's ironic that beautiful people often don't attribute much influence to circumstance, because the circumstance of being born beautiful can have a big impact on how they're treated by others.

The confidence and sense of control that they feel also translates into a greater sense of self-importance. In one experiment, people were kept waiting while the person who was supposed to be serving them talked on the phone. The really attractive individuals became impatient much more quickly than the less attractive people did.

Of course, great looks aren't the only source of confidence. People feel good about themselves and project self-assurance based on everything from their athletic or artistic ability to their intelligence or interpersonal skills.

As much as anything else, the research suggests that being

GUILTY!

Beautiful people are generally more effective at persuasion, which is why they often make good salespeople.

But studies show that under certain circumstances, this means very attractive people are *more* likely to be convicted and punished for crimes than unattractive people.

Faced with a good-looking person accused of swindling people out of their money, juries are inclined to believe that the beautiful or handsome defendant possessed the ability to charm innocent victims. It's as if juries equate the defendants' attractive features with the "tools" necessary to rip others off; they're more likely to judge such defendants guilty as a result.

treated well has an enormous effect on how people feel about themselves, no matter what they look like.

Great Expectations and the Power of Flirting

Then again, sometimes people live up to our expectations of them. One study had women and men who didn't know each other speak on the phone. When the men were given photos of beautiful women and told, "This is who you'll be speaking with," researchers noticed that they tried harder and were bolder and funnier than when they were speaking to women who they believed to be less attractive.

The women responded to the men who thought they were attractive by becoming bolder, more animated, and confident themselves. Treated as if they *were* interesting and exciting, they actually *became* more interesting and exciting—a kind of self-fulfilling prophecy.

No doubt you've witnessed or experienced the power of flirting, firsthand. A guy gives you a second look and it puts a bounce in your step. A girl speaks to you in an intimate way, and you're more inclined to respond in kind. Lots of people learn to use the art of flirtation to their advantage, whether or not they're beautiful. And the personality demonstrated by a sense of humor or witty reply can itself make a person more attractive.

CAUTION: BEAUTY AT WORK

HEIGHT ALSO MATTERS. Even if you have no desire to shoot hoops or walk a runway, it turns out that the "tall" part of "tall, dark, and handsome" translates into better earning power.

The average American man is five feet, nine inches tall, but more than half of the chief executive officers (CEOs) in the US's 500 largest companies are over six feet tall. Only 3 percent are under five foot eight. And even among non-CEOs, the inches translate into better pay—for every inch of height above average, taller men and women make about $789 extra a year.

Why? Experts believe it all comes down to assumptions. Taller people are no smarter or more competent than shorter people; we just imagine they must be, based on their height. This doesn't mean that the shorter in stature can't also become very successful, but they probably have to work harder to prove themselves than their taller colleagues.

Pretty women experience similar advantages—but only if they're applying for clerical work or for jobs that involve a lot of contact with the public. In these cases, stereotypical ideas about women—that they're warm, friendly, and eager to please—work in their favor.

The bottom line on beauty advantages is this: attractive people do have a bit of an edge over those who are less attractive. But beauty is only one variable in what happens in a person's life; despite the conclusions we apparently draw about those who are blessed with good looks. Looks are no guarantee of happiness or success. In fact, sometimes beauty can work against you in unexpected ways.

ONLY SKIN DEEP

EVEN THOUGH WE MAKE SOME POSITIVE ASSUMPTIONS about attractive people without knowing them, a person's beauty can also have a negative impact on how we rate their integrity, sensitivity,

or concern for others. In fact, we sometimes assume gorgeous faces belong to people who are snooty or self-absorbed. Apparently the fairy tale messages about beauty being only skin deep weren't completely wasted on us after all!

Good-looking people are less likely to get asked by others for help, although it's not clear why. Maybe people are intimidated by their beauty or assume that they're too self-important to bother. It may be an advantage not to be asked for favors all the time, but life could be lonely if everyone assumes you're unapproachable.

SNEERING PROMOTION

One Diet Coke ad features two women in their 30s sitting at a table and laughing. The headline on the ad reads: "The smug satisfaction you feel when you learn your ex's new squeeze has thick ankles."

The message seems designed to hook into the worst in people—as if catty sneering at the physical imperfections of others is a good way to feel better about yourself, or bond with your friends.

"Don't Hate Me Because I'm Beautiful"

Advertisements that invite us to compare our own imperfect bodies and faces to the impossibly buff and beautiful ones they use to flog products play a big role in inspiring feelings of inadequacy.

The "don't hate me" line was used in an advertising campaign for Pantene shampoo. By asking viewers not to hate the woman whose image appears there, the ad actually encouraged resentment by bringing up the idea in the first place. Without the slogan, it probably wouldn't occur to most viewers of the ad to hate the woman. What's more, the slogan implies that we *should* be jealous because, unlike the model, we're *not* beautiful—an unfortunate situation that could of course be remedied if we just bought the shampoo.

Living in a world that values good looks, many people do feel jealous of those who are more attractive. That's understandable. But the result is that beautiful women often have a harder time making

friends with other women. Researchers call this the "contrast effect." The idea is that since nobody likes to be compared with someone else unfavorably, hanging out with a hot friend causes those less attractive to think they look bad in comparison.

On the other hand, would being gorgeous make up for having to worry about whether or not people will hate or avoid you for it? A newspaper columnist whose appearance has inspired jealousy in others explains it this way: "People suspect those with very good looks," she writes, "and rightly so. It's an unearned advantage."

She has a point. In contrast to the hard work and effort people invest in developing a skill, running a successful business, or helping others, merely tumbling out of your mother's womb with a genetic package that's sure to turn heads does seem unfair. It's easy to resent the opportunities or attention another person gets because of something they had nothing to do with. "Why him or her," we think, "and not me?"

EASY COME, EASY GO

The problem with beauty is that it's like being born rich and getting progressively poorer.
—actor Joan Collins

Because youthfulness is a key aspect of our culture's beauty ideal, even people who are gorgeous in their teens, 20s, and 30s eventually start to notice that they don't receive as much attention as they get older.

This can be devastating. The aging process brings not only changes to their physical appearance but also a shift in the number of compliments and opportunities they receive. If you've become really attached to being appreciated for how you look, it hits you hard when the compliments stop. Others don't invest enough energy in developing other assets or strengths. The gradual realization that the cameras are now focused on a whole new crop of gorgeous teens or 20-somethings can result in depression and eroded self-esteem.

In some ways, growing older can be much easier for people who never thought of themselves as beautiful in the first place.

TOO CUTE

How stupid was the blonde? When asked the capital of Wisconson, she replied, "That's easy: W."

You've probably heard dozens of variations on the blonde joke. All of them assume that listeners understand that "blonde" means beautiful but not very bright. Implied is the idea that brains and good looks are incompatible.

Countless movies and TV shows have featured blonde characters who have reinforced the idea. Think Phoebe on *Friends*, for instance. And part of the humor of the *Legally Blonde* movies comes from turning the dumb blonde stereotype on its head. Reese Witherspoon's character comes across as ditzy and fashion-obsessed, so people underestimate her intelligence, and she uses that to outsmart them.

The truth is, of course, that good-looking people—blonde or otherwise—are just as likely to be smart, or not, as everyone else. But many people still unconsciously assume that a woman can't be both gorgeous *and* intelligent.

So while research has shown that good-looking women have greater success being hired for secretarial positions, they have a more difficult time landing more powerful jobs or promotions. Very attractive female lawyers, for instance, are less likely to be made partner in their law firms than less attractive colleagues. In business, beautiful women have a slower climb up the managerial ladder. Researchers say this is because, in contrast to handsome men, attractive women are perceived as sexy and submissive, not tough and decisive.

But it's all relative. At the other

HANDSOME DISADVANTAGES

Good-looking guys are also sometimes judged unfairly. Men who look especially macho—because they have prominent chins, a heavily ridged brow, deep-set eyes and wide or rectangular-shaped heads—are judged harshly if they don't also demonstrate leadership qualities of intelligence or courage.

Because they look tough and strong, they're expected to act that way. If they don't, people feel as if they've lied: their looks seemed to promise something that they didn't actually deliver.

In contrast, a man whose beauty could be called more "feminine"—featuring a high forehead, large eyes, full lips, small nose, or a delicate jawline—is more likely to be mocked or taunted by other guys about his manliness.

Believing that high heels make their legs look longer and more shapely, many women are willing to sacrifice comfort for appearance. But in the workplace, beauty can be a double-edged sword: women perceived as being especially sexy or feminine often have a harder time being taken seriously at a professional level.

● ●

end of the beauty spectrum are people who are judged to be especially unattractive; they have even more difficulty getting hired, promoted, or paid fairly, with none of the advantages that beauty gives people at the other extreme.

Many women have complained about the career obstacles they've faced because of their appearance. Candace Bushnell, author of the original "Sex and the City" column on which the TV series was based, says that long before her name became associated with the "sex" of her column, she often felt dismissed as a "pretty face." She says it made her angry not to be taken seriously, or to have people assume that she was one-dimensional.

Feminist activist and journalist Gloria Steinem, whose beauty was the subject of frequent media attention when she first started speaking out for women's rights in the 1960s, had a similar problem. An experienced journalist, she showed up with her writing portfolio at *Life* magazine in response to an employment ad. The man in charge of hiring took one look at her and said, "We don't want a pretty girl, we want a writer." She didn't get the job.

Even in the movie business where good looks are essential, having them can sometimes be a handicap. Blonde beauty Charlize Theron feels her acting ability is often underestimated because of her looks. "Most of the time I feel like directors don't even know what I'm capable of." Mark Wahlberg, who co-starred with

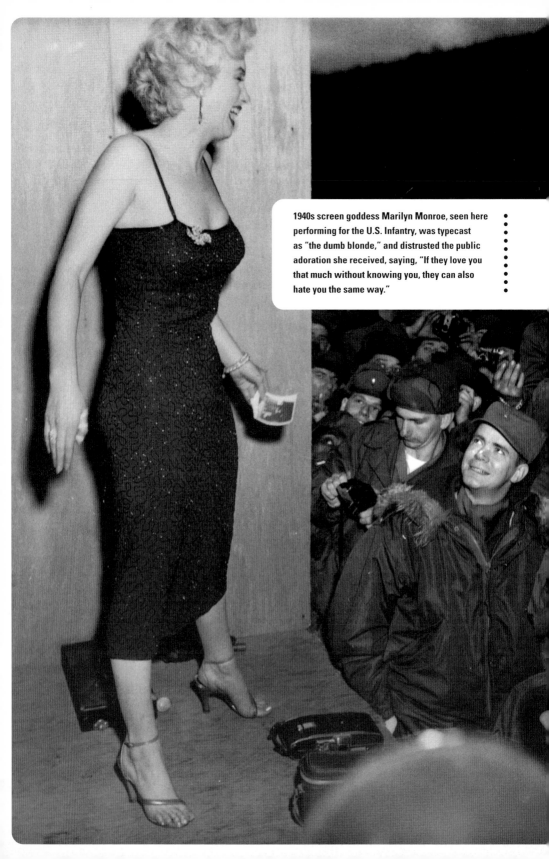

1940s screen goddess Marilyn Monroe, seen here performing for the U.S. Infantry, was typecast as "the dumb blonde," and distrusted the public adoration she received, saying, "If they love you that much without knowing you, they can also hate you the same way."

her in one film, agrees, saying it was hard for him initially to "get past her looks and see how talented she really is."

MORE THAN JUST A PRETTY PACKAGE

PEOPLE WHO ARE USED TO getting positive attention for their looks alone sometimes find it hard to trust that others are really interested in more than their physical exterior. Like most of us, they want to be appreciated for their personal qualities and feelings, too, or the talents they've worked hard to develop. Superficial responses make them question their own worthiness, or the sincerity of those around them.

I just feel that overall, I've been extremely lucky... I don't feel I deserve any of it.

—actor Mena Suvari

The very systems that celebrate beauty and ensure those who have it receive so much attention also make it hard for them to be appreciated for anything else. As problems go, you might think, "bring it on," but like lots of things in life—money, fame, intellectual brilliance—it's not as simple as it might seem on the surface.

> I was on the cover of Rolling Stone a couple of times, and when all they want to talk about is your haircut, it breaks your heart.
>
> —rock star Jon Bon Jovi

IMAGE REFLECTIONS

MUCH AS WE MIGHT WISH OTHERWISE, the truth is, life isn't always fair, and—just as you may have suspected—beautiful people do have some advantages. But studies suggest that those advantages are not really significant when compared to the kinds of things you actually have control over, like your interests,

personality, or attitude toward the world. So the following points are mostly about experimenting with that knowledge:

* Realizing that good-looking people get treated better than those who aren't is a good reminder of the fact that perceptions aren't reality. With that in mind, start noticing how you respond to people's packaging, and what kind of unconscious assumptions you make about them because of how they look.

* Try treating *everyone* as if they were beautiful—whether you consider them so or not. Do they become more confident, dynamic, and interesting in response? And do you?

* As big a factor as beauty is in our world, the truth is that *how* you approach your life will have a much bigger impact on where it takes you than what you look like.

CHAPTER

8

COMPETITION 24/7

There's no formal entry requirement for the beauty contest of life; just showing up puts you on the runway, whether you want to be judged or not.

On TV, *Joe Millionaire, The Bachelorette, Joe Average,* and *American Idol* have given air time to the vicious assessments some people make about others' physical charms—or lack of them.

Many women's fashion mags invite readers to rate guys based on their looks—*CosmoGirl* has a regular "Boy-O-Meter" feature, while *Elle Girl* asks for responses to the question, "Who is the butt-ugliest guy in rock?" Publications for guys also focus a lot of attention on the checklist of appearance "must-haves" for a woman to be deemed hot.

And at school, even though the criteria may not be posted on the bulletin board, there's often an unspoken consensus about what's hot, and what's not, when it comes to looking good.

ANCIENT BEAUTY RIVALRIES

THE FIRST RECORDED BEAUTY COMPETITION dates back to the days of Helen of Troy. She wasn't a contestant, but she was definitely implicated.

According to Roman mythology, Jupiter invited all the gods to a feast to celebrate the marriage of Thetis and Peleus. Somehow Eris (also known as Strife) was left off the guest list. True to her name, she showed up anyway and when they wouldn't let her in, she tossed an apple into the banquet hall from the doorway, proclaiming that the most beautiful woman should pick it up.

You can probably guess what happened next: a fight broke out. Juno, Venus, and Minerva all claimed to be the best-looking and when things threatened to get ugly, Jupiter ordered Alexander Paris to judge their respective charms.

Paris's task, however, bore little resemblance to the work of contemporary contest judges; no swimsuits, evening gowns, or skill-testing questions were involved. But being goddesses, Juno, Venus, and Minerva understandably invested all their energies in the "talent" portion of the impromptu pageant, anyway!

Paris was an ordinary mortal, with no godlike powers of his own. So each of the contending beauties tried to outdo the others with bribes. Juno promised to make Paris rich, Minerva pledged to give him wisdom and bravery, and Venus promised to arrange for him to marry the most beautiful woman in the world (this is where Helen comes in). In the end, Paris was more taken with the idea of having a gorgeous babe on his arm than he was with untold riches or power, so he declared Venus to be the best-looking of the three.

Like the Greek myths we looked at in chapter 1, Paris's story is a cautionary tale reminding us of the dangers of beauty and its seductive powers. You may recall that hanging out with Helen was no "happily ever after" scenario for Paris: the two lovers running away together started the Trojan War!

BATHING BEAUTIES: A TOURIST ATTRACTION

THE FIRST REAL-WORLD BEAUTY COMPETITIONS weren't nearly as dramatic. In the medieval era, festivals such as the English May Day celebrations began the practice of selecting "queens" who served as symbols of the rebirth of spring. But the real precursor to the kind of organized contest we associate with Miss America or Miss World didn't show up until the 1850s.

Around this time, P.T. Barnum (of Barnum & Bailey circus fame) operated a popular museum in New York City, hosting all kinds of "national contests" in which dogs, chickens, and flowers were judged and gawked at by museum visitors. But Barnum couldn't persuade respectable girls and women to take part in such an "improper" activity.

To overcome this reluctance, he hit on the idea of inviting the women to submit their photographs instead, promising to commission oil portraits of the top ten entrants. He appealed to Victorian snobbery, craftily claiming that he was trying "to encourage a more popular taste for the Fine Arts to stimulate... the genius

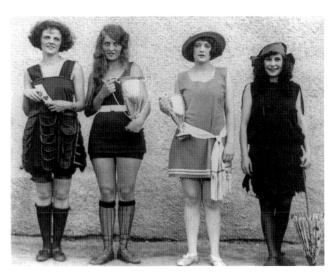

These contestants competing in the Washington Bathing Beach contest in 1922 may not have known it, but they were seen as a tourist attraction. Local community officials were counting on them to bring visitors—and their dollars—to the city.

of our Painters." In fact, he simply wanted to increase traffic to his museum. The ruse worked and women entered in droves.

Other entrepreneurs recognized a money-making idea when they saw one. By the early 1900s, all sorts of beauty contests had been established in which babies, toddlers, teenagers, and adults were paraded in front of audiences in order to be judged on the basis of their looks. Prior to this time, such displays had been reserved for livestock.

The first Miss America pageant was held in Atlantic City in 1921. City officials hoped that assembling a bunch of attractive young women in bathing costumes might help them to lure more tourists to visit the seaside resort after Labor Day weekend.

By the early part of the 20th century, social views had softened, and many young women entered the competitions believing that if they won, the profile they gained would change their lives for the better. At the time, very few girls expected to go on to university—unless it was to obtain an eligible husband. If they had to work, their choices were typically limited to the designated female professions of store clerk, secretary, teacher, or nurse. You can understand the appeal of the beauty pageant: it had the potential to open the door to more opportunities.

PAPER BAG OVER THE HEAD CONTEST

Just a few years after the Miss America pageant began, a New York City newspaper launched its own contest, inviting young women to send in their photos in the hopes of being judged "the homeliest girl."

Although it may seem surprising that anyone would enter such a competition, the lure of receiving free plastic surgery and an opera audition was enough to convince some girls to submit their pictures to be judged by readers of the paper.

These were neither numerous nor guaranteed, but they could net a beauty queen some modeling or acting work, which tended to be more glamorous and better paying—if ultimately short-lived—than the alternatives.

Many pageant winners, then and since, have indeed gone on to greater things. After Vanessa Williams became the first African American to win the crown in 1984, she established a successful acting and singing career. Others have managed to overcome the beautiful-but-dumb stereotype that sometimes sticks to beauty contestants to become respected TV journalists, business executives, or CEOs.

Bodybuilding began in the late 19th century at the same time as the introduction of photography, which made possible the distribution of striking images of muscle-bound guys to a large audience. This bodybuilder is competing at a 1999 contest at Venice Beach, California, home of the original Gold's Gym.

NO BOYS ALLOWED

Beauty pageant contestants are almost always women and girls.

Bodybuilder contests are an exception, but by their nature they attract less media attention. Arnold Schwarzenegger, who won the Mr. Universe title five times and the Mr. Olympus title seven, is world-famous today, but more because of his subsequent career as a Hollywood action hero and politician than because of his "beauty" crowns.

This is not to say that men aren't expected to compete with each other, just that their contests have typically been played out in the realm of sports, business, or politics—where they're judged on the basis of what they know or can do, as opposed to simply on how they look.

The stepping-stone possibilities are part of the appeal of beauty pageants even today. And they help to explain why the contests are more popular in rural areas than they are in big cities. Career opportunities are a lot more plentiful in Dallas, Philadelphia, and Calgary than they are in Ferndale, Needham, or Wakefield. For many pretty girls from small towns, beauty pageants still seem to promise a more exciting and glamorous life.

CHALLENGES TO THE "CATTLE SHOW"

Despite the popularity of pageants, and the fantasies they feed in young girls who dream of being crowned the fairest of them all, beauty contests have continued to attract controversy over the years.

In 1968, a couple of busloads of women showed up at the Miss America pageant site not to ooh and ahh over the contestants, but to protest the competition itself. Their activities were designed to point out that pageant participants were being used as attention-getting objects to sell products or travel destinations. They wanted people to question the practice of judging women and girls on the basis of their physical appearance like animals at a county fair.

The protesters crowned a live sheep and held up a poster featuring a naked woman whose body parts had been labeled "rump" and "loin" as if she were a side of beef. The publicity stunt challenged the way many people looked at the treatment of women generally, and at beauty pageants in particular.

In the years following the protest, perspectives on the rights and roles of women continued to shift, and different career opportunities contin-

In the late 1890s, the famous actress Sarah Bernhardt was criticized for being too skinny, even though she would never be described that way according to today's standards. Our tendency to judge people on the basis of their looks—regardless of whether or not they've entered a formal contest—shows that although the criteria for success may change from one generation to another, the beauty "competition" itself has been around for centuries.

ued to open up for girls. As a result, beauty pageants began to lose some of the prominence they'd once had. Then fashion advertising, music videos, and more recently, reality TV shows made beautiful, sexy young women more visible, and televised beauty pageants became even less of an audience draw.

In recent years, a number of news stories have also focused attention on the ugly underside of the competitions, tarnishing the reputation of beauty pageants everywhere:

* A journalist in Spain successfully bought her way into the winner's circle of a pageant, and then wrote an exposé about how crooked the organizers were;

* Religious and cultural opposition to the 2002 Miss World pageant being held in Nigeria resulted in riots that left more than 200 dead;

* Several beauty queens have been publicly chastised by pageant organizers for disgracing themselves and their crowns by lying about their marital status; concealing the fact that they've had children; becoming drunk in public and getting into a fist fight; and gaining too much weight.

In response to these stories, observers have questioned the right of pageant organizers to dictate the past or future behavior of contest winners.

But like P.T. Barnum, pageant organizers persist. They're confident that, as long as the world

TRIUMPH OF THE BULLIED

Erika Harold had a challenging time in high school. Of mixed race, she describes herself as black, and as a teenager she was targeted by bullying and racism.

But she refused to be defeated by the harassment and now she's had the last laugh: in 2003, the Phi Beta Kappa graduate entered the Miss America contest, spoke openly about "Empowering Youth against Violence"—and won.

Now on her way to study law at Harvard, she's taking advantage of the attention she gets for her looks and her crown to shift the spotlight onto issues that are important to her. Her philosophy? "If you can find some way to be who you want to be and make a difference in society, you'll have a life worth living."

rewards young women for living up to certain beauty ideals, there's money to be made from holding contests that judge one girl to be prettier than all the rest.

THE CRUEL SCHOOL OF STEREOTYPES

EVEN IF YOU'VE NEVER BEEN REMOTELY INTERESTED in strutting your stuff in pursuit of a tiara, or oiling yourself up to pump iron in front of TV cameras, it's still hard to completely avoid the daily beauty pageant of life.

And high school is often where the toughest judging takes place. That thing about beauty being only skin deep? Try telling it to anyone who has to walk by the cool crowd or the jocks to get to class. Many kids feel as if their looks are being critiqued every time they walk down the halls. And often they're right.

A lot of teens mark each other as hip or nerdy based on everything from facial features and body shape to clothes, makeup, and hairstyles. The judgments can ultimately have a huge impact on not just who's popular, but on who gets ridiculed, harassed, or simply ignored. In some cases, the social stigma of not fitting in or being judged a geek is so severe that kids change schools just to escape the way they've been labeled.

• •

Uniforms—once the mark of students attending private school— are now starting to show up in some public schools. The reasoning is that losing a bit of personal expression is justified if it helps eliminate the kind of peer pressure and bullying that can go on in the name of brand-name fashion.

It's not exactly the kind of problem that's easy to report. And being told by adults that the kids who put others down invariably do so out of their own feelings of insecurity doesn't change the pain of the experience.

In an effort to even the playing field on the clothing front, and to minimize distinctions between students with lots of disposable cash and students without, some public schools have introduced uniforms. The theory is that if everybody's dressed the same, nobody gets judged on where they bought their jeans or whose logo is splashed across their T-shirt.

It's not that simple, of course. Kids just come up with different means of distinguishing themselves—hem lengths, jewelry, tattoos... The criteria may change, but the feeling of having to compete often remains the same.

CHILL-OUT STRATEGY

People who get petty and competitive over beauty issues are probably more likely to worry about being laughed at or criticized themselves. It's like the expression, "Live by the sword, die by the sword." If you put others down for their minor fashion faux pas or bodily faults, you invite the same kind of treatment.

Next time you find yourself mentally evaluating someone else's appearance, try focusing on only what you find appealing—the color of their shirt, confidence of their walk, cut of their hair… Avoiding a critical mindset around others also makes it less likely that you'll be hard on yourself.

THE UN-WINNABLE MEDIA MATCH

BEYOND THE SCHOOLYARD IN THE WIDER WORLD, the stakes seem just as high, or higher. The beautiful people who populate movies, advertisements, fashion spreads, and TV shows set an impossibly unrealistic standard against which we all feel measured.

This is particularly true for women and girls. Just think about the most visible (in more ways than one!) female characters on prime-time television and in Hollywood movies: the actresses who star in *The OC, Friends, Sex in the City,* and *Charlie's Angels* are, without exception, both slim and curvy. And the female models on magazine covers and in fashion ads have unbelievable bodies that don't seem to occur very often in nature.

Popular entertainment media feature good-looking guys, too, but TV shows and films also typically have more roles for male characters who are merely average in appearance. Also, guys' bodies are not normally on display in the way that women's bodies often are.

How does this affect the way viewers feel about their own appearance? In a word, badly. All sorts of researchers have studied the issue, and here's what they've found:

* Women and girls become less satisfied with themselves, and more critical of their appearance, when they're exposed to unrealistically thin and beautiful models and actors.

* The more time women and girls spend watching TV shows and reading magazines, the more likely they are to be negatively affected, and to become obsessed about their appearance or to develop an eating disorder.

• •

Women's fashion magazines do a lot more than showcase current clothing and makeup trends; their often relentless focus on body image has a big impact on both guys' and girls' attitudes about the ideal female body. Many experts believe the magazines contribute to disordered eating and feelings of insecurity.

* Male viewers were more critical of the appearance of average-looking females after looking at pictures of beautiful models. In extreme cases, guys can develop what's called "Centerfold Syndrome"—they get so used to seeing images of unnaturally sleek, buffed women that they become unable to form relationships with real women.

* Prime-time TV reinforces the ideas that 1) appearance issues are primarily something for women to worry about; 2) the way for them to attract men is by achieving a slim figure; and 3) it's normal behavior to comment on attractive women's appearances.

FALSE ADVERTISING

Here's a bit of encouraging news for girls who didn't happen to be born with the body of a coat rack: just because female actors and fashion models typically look like they've never met a piece of cheesecake they were prepared to eat doesn't mean that the average guy prefers the anorexic look.

In fact, he doesn't.

The exceptional slimness of female stars encourages women to believe that guys like scrawnier bodies than they actually do. Really, the slimness craze is driven more by fashion designers than the tastes of men —designers think their clothes hang better on bony bodies.

But when Charlize Theron gained 30 pounds for her role in Monster, she was too big to fit into even her boyfriend's clothes, and had to practically live in sweatpants. Far from objecting, her boyfriend "started liking it [her heavier body] a *lot*."

While girls' and women's career opportunities have expanded enormously in the past few decades, media images and the pressure to conform have become increasingly unrealistic. The unconscious message is, "Sure, you can be an astronaut, dentist, or stockbroker, you can operate heavy equipment, judge complex court cases, or fight fires, but you'd better be skinny and beautiful, too."

Comparison Technology

In this age of mass media, where we're surrounded by images of other people all the time, it's almost impossible to imagine living a few centuries ago when the only faces and bodies we would be really familiar with would be those of our relatives and neighbors, people who lived nearby and interacted with us on a regular basis. Without the constant comparisons provided by media—or even mirrors—we'd still notice who was good-looking and who wasn't, but we wouldn't think about it nearly as much.

When photography was first invented and people saw their images on film for the first time, many were unhappy with the result, and some even requested changes! Not used to seeing themselves captured in print, they found the experience very jarring. Even today, most of us think we take an occasional good picture, but are sure (or at least hope) that we look better in real life.

Photography first started to change how individuals thought and felt about their looks, but then mass media—magazines, film, and television—had an even bigger impact on people's sense of themselves. Suddenly, the number of people they knew and saw regularly expanded exponentially to include all sorts of people they would never, ever meet, but whose appearance became familiar and widely discussed.

With each new technological advance, the beauty stakes get

LIGHTS! CAMERAS! CLEARASIL!

It's not the kind of call you'd expect to hear on a Hollywood set, but the invention of high-definition television has introduced a new level of realism to TV production that not everybody's ready for. The exceptionally clear image produced by the new technology exposes the kind of skin flaws that makeup used to be able to conceal.

This is causing problems for stars like Cameron Diaz who, as pretty as she is, has wrestled with a longtime acne condition that has left her skin pockmarked.

Now makeup artists are scrambling to adapt the airbrushing that's used to subtly alter photographs for cosmetics. They're developing a thin, water-based liquid that they can spray-paint onto faces in order to hide imperfections that weren't previously visible on a regular TV screen.

higher for everybody. Being thought good-looking within our family or neighborhood isn't nearly as impressive anymore. Consciously or unconsciously, we're being compared to screen gods and goddesses who, in addition to having won the gene lottery in the first place, are dressed in gorgeous clothes and attended to by hair and makeup artists.

As if that isn't difficult enough to compete with, the images of beautiful people pouring out of the entertainment industry become further and further removed from reality. Special lighting, airbrushing, and computer graphics programs have all helped to create pictures of people that bear less and less resemblance to the reflections in their own mirrors.

UNNATURAL BEAUTY SECRETS

MOST FASHION PHOTOGRAPHS are retouched these days. According to a former editor at *Vogue* and *Harper's Bazaar*, current technology allows art directors to "do anything." Common touch-ups include everything from trimming the model's waist and enlarging her breasts, to changing the contours of her face or the color of her skin.

> Beauty is a collaboration between the photographer and the makeup and hair specialists. I am the final result of their work.
>
> —model Naomi Campbell

Former supermodel Christie Brinkley says that even she can't live up to the images of perfection displayed in contemporary women's magazines, cautioning women that the magazines "overexaggerate and overemphasize to make a point, and you shouldn't try to copy it."

Despite the reputation that models and performers have for undergoing all sorts of procedures in order to counter Mother Nature and look their best, some are starting to feel that the alteration trends have gone too far.

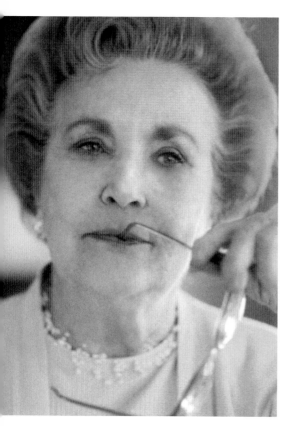
Who needs Botox when you've got Photoshop? Computer programs can eliminate age spots, erase wrinkles, and color hair with the click of a mouse.

British movie star Kate Winslet is curvy by nature and has often spoken out about her unwillingness to knock herself out in an attempt to mimic Hollywood's slim ideal. And when *GQ* magazine trimmed her thighs in a recent cover photo, she issued a press release to protest the change, wanting to make sure people realized the image wasn't completely real.

Middle-aged actor Jamie Lee Curtis, whose legendary body has been the focus of close-up camera attention in a number of movies, went even further. She approached the editor of *More* magazine, geared to older women, and offered to pose in everyday underwear (as opposed to sexy lingerie) without special lighting, makeup, hairstyling, or computer enhancement of any kind.

In a subsequent interview with *People* magazine, Curtis said that she wanted people to look at her and realize that without all the cosmetic work, many movie stars look pretty ordinary. She also confessed to having tried a number of age-defying beauty procedures. "It made me look worse and feel worse. What they say works, doesn't. People think there's a fix for everything and there's not."

Men Are from Mars, Super Models Are from Pluto

Just how extreme is the media's version of the beauty competition? Think of it this way: the judging criteria for earning a spot

in the rarefied world of female fashion models is so narrow that most girls have a better chance of winning a lottery.

Bobbi Brown has applied makeup to the faces of many American stars in her job as beauty editor at NBC. She provides some sobering context for how tough the competition is in the fashion modeling industry: "For every one hundred girls who step foot into the major American modeling agencies, only one will actually get signed by them. Even then, her chances of making it are slim... Approximately only one model in ten thousand will be able to make it her career."

The window of opportunity for acceptance as a model is extremely short. Girls as young as 12 and 13 are sometimes recruited by scouts. If you haven't been "discovered" by the time you've hit 17, the chances are slim to none that you ever will be.

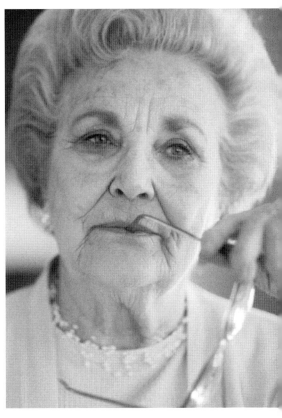

Most fashion spreads and beauty ads feature only the "after" pictures, not the "before," making it easy for us to forget that the commercial images we're looking at don't reflect reality.

Measuring Up... to Barbie?

* The average North American woman is 5'4" tall and weighs 142 pounds. The average female model is 5'9" tall and weighs 110 pounds.

* If Barbie—as in the doll—were a full-sized human being, her measurements would be 39-21-33; she'd have to have all her clothes custom-made.

✱ One academic expert figured out that a woman's chances of having a figure like Barbie's were less than one in 100,000.

Most females couldn't achieve the waif look even if they tried, but many have died in the attempt. The tall, slim physique prominent on catwalks and in fashion ads is something very few people are born with, and almost nobody can maintain indefinitely. To do so typically requires chronic dieting, disordered eating, drug abuse, or manic exercise, and often the loss of so much of the body's natural fat that you stop having your period. This is the body's personal form of protest—a message similar to the graffiti once scrawled on a billboard image of Kate Moss. The supermodel looked so unhealthy in the jeans ad that someone had spray-painted across the bottom of it, "Give me a cheeseburger!"

Female athletes have a bit more leeway on the body-image front: if you're muscular like Serena Williams or Anna Kournikova, you don't have to live up to waiflike images. But don't forget that these women spend a big part of most days working out—with the help of personal trainers or coaches—in order to maintain their edge.

IMAGE REFLECTIONS

BEAUTY PAGEANTS BECAME POPULAR at a time when women didn't have a lot of career options. Now they do. Even though it sometimes seems as if anyone who's anybody is on the cover of a magazine, the truth is that looking gorgeous for a living is exactly that: a job.

Living in North America, it's hard to completely escape the pressure to compare, compete, or conform to the ideals of beauty being promoted all around you—especially if the fashion police seem to have taken over your school. But only *you* get to decide how much of a priority it's going to be in your life. So:

* There's nothing wrong with making the most of the physical appearance your genes have handed you. But studies show that investing equal time in developing your abilities in the "talent" and "skill-testing question" categories pays off: girls who value other things about themselves—their intelligence, athleticism, ability to play a musical instrument, close relationships with friends—aren't nearly as affected by impossible media ideals.

* Time spent *doing* means less time *comparing*—and that translates into more confidence.

* Beauty resentment can infect friendships and erode self-esteem. The only people who win when appearance rivalry gets ramped up are the ones getting rich off fashion and makeup sales.

FLOGGING FANTASIES

You don't have to resemble the orcs from *Lord of the Rings* to occasionally feel like you're in serious need of a new and improved look. And these days, there's no limit to the sources of inspiration and help you can turn to.

The drugstore on the corner has hundreds of moisturizers and cosmetics, all promising great things; the beauty salon down the street pledges to completely transform your face, fingernails, and hair; and the nearest shopping mall is teeming with "style consultants" who would like nothing better than to sell you the latest must-haves.

Even the magazine rack at the newsstand is offering "245 tips to get your hottest holiday look," "325 ways to go wild with your style," plus advice on achieving "sexier hair," "fetching eyes," "thinner thighs," and "awesome abs."

Women have been using cosmetics for centuries, but until very recently they had to make the stuff themselves, at home. It wasn't until the early 1900s that beauty aids and makeup become widely available in stores.

• •

Today's beauty business is a multi-billion-dollar industry. Huge international companies make and market thousands of personal-care products, from hair dye and eyeliner to leg wax and foundation—every beauty aid you could possibly think of, and many more that would never have crossed your mind!

The challenge is in wading through them all and figuring out which—if any—are the answer to your beauty woes. In the process, you might wonder how you came to think you had such woes in the first place!

MAKEUP MAKEOVER

MAKEUP OF ONE KIND or another has been around for centuries, but it's gone in and out of style many times. During some periods, it was seen as an essential component of every fashionable woman's (and occasionally man's) beauty regime; at other times, it was so negatively associated with actors and prostitutes (professions that were sometimes viewed as being interchangeable) that no "respectable" female would touch it.

Even as recently as a hundred years ago, most North American women wouldn't have dreamed of wearing makeup and beauty contestants were absolutely forbidden to do so.

But during the 1800s, some savvy businesspeople began to recognize the money-making opportunities in manufacturing and selling beauty aids. They set up companies to not only

make personal products, but to convince people that they really couldn't live without them.

Beauty by the Numbers

Today in the US, more money is spent on beauty than on education.

It's estimated that every year, Americans fork out at least:

* $20 billion for diet products and services
* $9 billion for plastic surgery
* $8 billion for skin care
* $8 billion for hair care
* $6 billion for makeup
* and even $1 billion for products and services!

BANNING BEAUTY DEVIOUSNESS

Toward the end of the 18th century, members of the British Parliament attempted to pass a law preventing women from "trapping" men with artificial means.

The politicians were concerned that devious women could so effectively disguise their physical flaws with makeup and other artifices that poor, unsuspecting men would be tricked into marrying them under false pretenses.

The proposed law never passed, though, because they couldn't figure out a way to enforce it.

Successful cosmetics companies can usually afford to pay lots of money for advertising and promotion; the human desire to be attractive is so strong that the profits earned from appealing to our vanity more than repay the investments made.

But the next time you find yourself being seduced by a zit creme or hair conditioner claiming to be "new and improved," it's worth remembering that beauty companies typically only spend between 2 and 3 percent of their sales revenue on developing better products. In contrast, they spend between 20 and 25 percent producing new packaging and figuring out how to promote the products in such a way that you'll become *convinced* they're new and improved.

Up to 40 percent of the price of every tube of lipstick or jar of hair gel is needed to pay for the marketing. So if you pay $40 for a bottle of the latest perfume or cologne, as much as $16 of your money is paying not for the ingredients, but for the ads the company used to persuade you to buy it in the first place.

Some of that money goes to beautiful models; even the beginners earn an average of $1,500 a day. For context, the starting salary for an elementary school teacher or firefighter works out to about $200 a day. But top-tier models come at an even steeper price, earning as much as $25,000 a day—more than many people earn in a whole year! And if you really want the money you spend to go toward the model's salary, as opposed to the product itself, buy something promoted by one of the two dozen supermodels: Naomi Campbell earns $100,000 *a day*.

Nice work if you can get it, but maybe not something you want to have to pay for yourself!

Because You're Worth It!

In a famous advertising campaign for L'Oréal, actress Cybill Shepherd tossed her silky blonde hair and claimed that she used the hair color because "I'm worth it!"

On one level, the slogan was a clever way to play on the traditional idea about women having a duty to make themselves gorgeous for guys. When the L'Oréal campaign was first launched in 1972, debate raged about the importance of equal rights for women. So although the company was selling beauty improvement products, its emphasis on the *woman's* worth was an appealing message. The "I'm worth it" slogan told women that they were important, and deserved to do something special for themselves.

Boys Will Be... Beautiful

Even men spend more than nine and a half billion dollars a year on plastic surgery, cosmetics, fitness equipment, and hair products.

Unlike previous generations, many guys no longer feel their masculinity is threatened by engaging in beauty behavior that used to be seen as the exclusive domain of women. Some experts estimate that close to 35 percent of men between the ages of 18 and 34 now regularly buy skin-care creams and cologne. British soccer star David Beckham is a particularly high-profile example of the kind of guy who's comfortable buying designer clothes and getting facials. He's become almost as famous for wearing sarongs, earrings, and elaborate hairstyles as he has for his skill on the soccer field.

It seems that the beauty business has successfully convinced at least some men that salon-style pampering and attention to personal appearance is no longer just for girls.

Hope in a Jar

Charles Revson, founder of Revlon Cosmetics, was very clear about how the beauty business worked. He said:

In our factory, we make lipstick; in our advertising, we sell hope.

In other words, lipstick is just colored wax in a tube, but the advertising is where the real magic happens. We so want to believe that our appearance can be improved—that we, too, can look like the models in the ads—that we'll buy all sorts of stuff on the basis of the promises made, even when our previous experiences have taught us that that's unlikely.

Judging by the success of big companies like Maybelline, Max Factor, Estée Lauder, and Clinique, the strategy is working. We're spending more and more money every year, hoping that this moisturizer or that mascara will hide our flaws or transform us into the hot property we've always dreamed of being.

Constantly surrounded by images of women and girls wearing cosmetics, some start to feel naked or invisible without it. But does makeup guarantee an improved appearance?

At the very least, when artfully applied, it *can* help to draw attention to some features and de-emphasize others. Using dif-

ferent products, colors, and techniques, eyes can be made to look bigger, farther apart, and less tired. Concealer can cover up blemishes, gloss and liner can enhance lips, and rouge can add a healthy-looking glow and make cheekbones appear more prominent. As more and more products become available, the potential for improvement might seem limitless—especially to the cosmetics companies.

But judging "improvement" can be highly subjective. It depends a lot on what kind of look appeals to you. While one person admires shimmery eye shadow and bright pink lip gloss, another prefers the dramatic contrast between stark white foundation and jet-black hair.

Standing in line at a department store, you may conclude that the blood-red nail polish worn by the woman ahead of you makes

her resemble Dracula's bride; she may think that your thick black eyeliner gives you an unfortunate raccoon look. Meanwhile, the cosmetics-free woman behind you may look at you both and think that *au naturel* is much more attractive.

Despite the hype, many women still choose to wear little or no makeup. Their reasons are probably as different as they are. They don't want to spend the money or the time; they're allergic to the products; they don't like the feeling of stuff on their faces; they find it harder to be taken seriously in their professional life; they've tried it and decided it didn't make much of a difference; they equate makeup with a mask, and concealing the real them; they've accepted their faces, flaws and all; or they just don't believe any of the claims that cosmetics companies make.

PROMISES, PROMISES

CERTAINLY BRINGING A CRITICAL EYE to the industry's promotional hype is a beauty investment that pays off for everyone. Learning to read between the lines when considering whether or not to part with your hard-earned cash at the makeup counter will save you disappointment.

You can't get more than a dozen pages into the latest fashion magazine without the promises piling up:

"Sky-high curves" for your eyelashes
"Dramatically whiter teeth in just two hours!"
"Dazzling, plumping lip color"

And one shampoo ad really goes out on a limb, offering not only to transform your hair "so it's soft, silky, and full of life," but to "revitalize you," too!

How do you actually measure whether or not these products deliver? Clearly "sky-high curves" is an exaggeration you're not even expected to believe. But how does lip color "dazzle," and who's to decide whether the improved whiteness you notice after "just two hours" qualifies as "dramatic"? And what would a

shampoo have to contain in order to actually make you more revitalized?

Such vague and meaningless phrases are invariably accompanied by pictures of fabulous-looking guys and girls who have the perfect teeth, glossy hair, or exceptional eyelashes being promised. But it's key to remember that, whether a promotional campaign features a world-famous actor or an anonymous model, the photograph is completely irrelevant to the effectiveness of the products being sold.

The truth is, the women and men who are shown in the ads are chosen because THEY ALREADY HAVE GORGEOUS SKIN OR FABULOUS HAIR! And the reason they're prepared to smile out from billboards or coo into TV cameras is because they're being paid a whack of money to do so. Their role is similar to the sales-clerk at the local car dealership. It's a job, not a scientific experiment with results you can replicate on your own body parts.

In fact, science is capable of disproving much of the hype. For instance, some dermatologists point out that adding vitamins, minerals, and herbs to many beauty products does nothing for the health of the skin. Usually, the doses are too small to have any effect, and when mixed with other ingredients, they lose their effectiveness. As just one example, vitamin A breaks down almost instantly when added to a cream. Says Dr. Albert Kligman, a dermatology professor from the University of Pennsylvania School of Medicine, "You make it up and two days later you have half of what you put in. Two months later, you ain't got nothing."

Even if an ad claims that "test results demonstrate..." ask yourself: What tests? On whom? Under what conditions? And, more importantly, who conducted the tests? If it was the company itself, how objective or reliable are the results likely to be?

You can start to notice which phrases suck you in, and then look at each word individually. "Soothing botanicals" are basically plants, and plants aren't inherently soothing. "Natural" and

"pure" have become associated with concepts of health and safety, but lots of "natural" substances aren't remotely healthy. Poison ivy is natural, and lead might be pure, but you wouldn't want either anywhere near your face!

Beware, too, of any claim with "may," "seem," or "appear" in it—as in "makes dark circles seem to disappear." These are wriggle words that are deliberately vague.

Both Canada and the United States have regulations designed to prevent advertisers from making false claims in their promotions. But many of the terms and expressions used in cosmetic and beauty ads are ambiguous enough that they fall through the cracks. So as with many consumer products, a good attitude to adopt in general is "buyer beware."

And don't forget that ads aren't the only source of suspect information. Product packaging is typically just an extension of

IS IT THE LINGERIE OR IS IT THE AIRBRUSHING?

When one newspaper journalist went behind the scenes at a photo shoot for a lingerie advertising campaign, she discovered the following tricks of the trade:

* rubbery skin-tone bust pads are inserted into models' bras to lift up their breasts and make them appear larger;
* the models' skin is moistened with water or shimmering makeup to make it glisten;
* dramatic lighting is used to enhance the effect;

* many poses are attempted (twisting the model's waist, squaring her shoulders, tousling her hair) in order to find the one that puts the lingerie in the best light.

Once dozens of photos have been taken and the best one selected, the airbrush artist steps in to:

* remove a mole, scar, blemish, or tattoo;
* intensify the model's eye color;
* even out her skin tone;

* remove any stray hairs;
* change the garment color; or
* add shadows to cleavage or abdomen in order to make the breasts look bigger or the tummy more toned.

Retouching can also lengthen limbs, trim curves, change hair color, and add contouring to a model's face or figure so that it's hard to know where the woman stops and the manipulation begins!

the ads themselves, written to puff up the so-called *amazing qualities* of what's being sold.

Featured Puff

You have to read between the lines in magazine articles, as well. Most magazines wouldn't exist without the money that big companies pay them for advertising space. As a result, some mags offer advertisers special bonuses in the form of photo features and sidebars that are really advertisements disguised as objective information. Recognizing that readers are more likely to believe the claims made in an article versus an ad, advertisers often demand both. They pay for a full-page ad, and in addition, they expect the magazine writers to mention their products in the editorial parts of the magazine.

NO ANKLE-BITING

You won't see many articles in most women's magazines that offer a critical view of any of the beauty practices featured elsewhere in the magazine. The people running the publications are careful to avoid printing stories that might upset the advertisers who support them.

As Helen Gurley Brown, the long-time editor of *Cosmo*, explained, "Having come from the advertising world myself, I think, 'Who needs somebody you're paying millions of dollars a year to come back and bite you on the ankle?'"

This means there's less emphasis on home remedies—like the use of sliced cucumber or used tea bags to reduce puffy eyes—than there is on store-bought treatments. The beauty of the month will be made up with products advertised elsewhere in the magazine, and the seemingly random list of hot new products being recommended by the publication's makeup specialist will feature the stuff heavily promoted in paid ads.

So try this: next time you read an over-the-top endorsement of some new cleanser or notice that the magazine makeover features a lot of a particular makeup line, flip through the pages. The chances are high that you'll discover ads for those particular products or companies.

THE CREDIBILITY DIET

HERE'S A SKILL-TESTING QUESTION: the cover of a magazine promises you details of a new diet that will allow you to lose 10 pounds in 10 days so you can fit into those jeans you grew out of two years ago. Do you spend four bucks on the magazine, or save up to buy a new pair of jeans that actually fit?

Weight-loss schemes—including diets, pills, supplements, and special programs—are among the biggest scams going in the beauty business. Despite years of accumulated evidence proving that very few of them actually work, the companies selling promises of guaranteed slimness continue to make millions.

But most of us know better than to believe that we'll lose five pounds a week eating all the protein bars we want, or drop three dress sizes in a month just because we start every day with grapefruit. Magazines or advertisers making these promises are just counting on making money off our ignorance and gullibility. The reason they succeed is because of the stigma North American culture attaches to being overweight. And the more attention the media give to weight-loss schemes, the bigger the stigma becomes.

But here's the scary part: for many people, the more they diet, the fatter they get. The US Federal

The first dieting craze began in the 1920s when fashions de-emphasized women's curves and exposed more of their arms and legs. One cigarette advertiser used the new, slim ideal to encourage more women to take up smoking—with the slogan "Reach for a Lucky Instead of a Sweet."

Trade Commission estimates that 50 million Americans will go on a slimming diet this year, but that only 5 percent of them will succeed in losing weight and keeping it off.

When the Remedy's More Dangerous than the Disease

If you had 20 pounds to lose, would you willingly trade them for heart problems, insomnia, or drug addiction? Lots of people have, without realizing that was the deal. Diet pills and weight-loss supplements are often made to sound like salvation in a bottle and the information provided in promotional materials tends to downplay the possible side effects. But as a result of serious medical problems and even a number of deaths, diet drugs like Redux and herbal weight-loss supplements like ephedrine have been banned in recent years. If your family doctor isn't recommending it, it's probably not a good idea.

As with cosmetics advertising, it's handy to adopt the skepticism of a supreme court judge when considering the claims made by diet products or programs. Beware of medical-sounding jargon, of "secret formulas" or anonymous studies. Watch out for personal testimonials, too. Even if the thinner, happier people featured in an ad's after photos aren't celebrities, the chances are they've been paid to tell "their story" and to imply that what worked for them, will work for you.

Comprehensive weight-loss plans certainly help some people, but they, too, have their critics. Undercover journalists

STARVATION RESPONSE

A key reason why most diets don't work in the long term is that when you restrict the amount of food you eat, your body gets nervous about not being fed and goes into starvation mode. It starts working hard to hang on to its fat reserves. So even if you shed pounds, they're often water and muscle, as opposed to fat. And when you go off the diet, you gain the weight back.

Another thing researchers have noticed is that people on diets often become obsessed with food. Our bodies are like little kids: tell them they can't have something and they can't think of anything else!

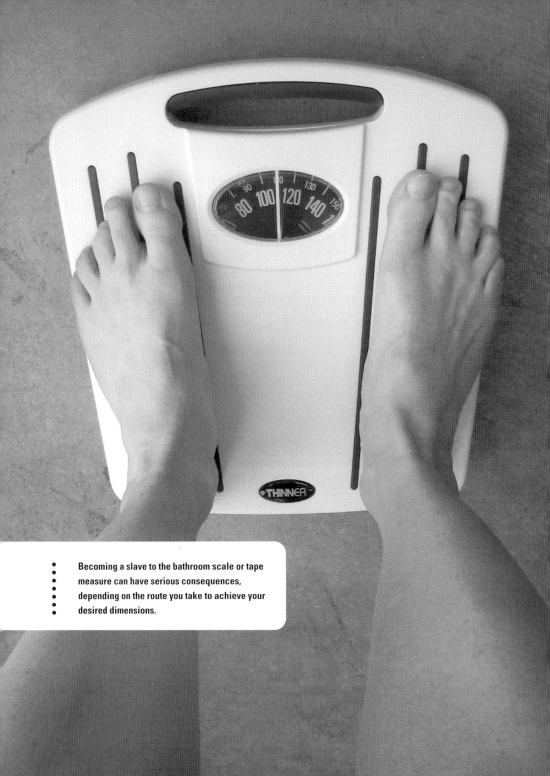

Becoming a slave to the bathroom scale or tape measure can have serious consequences, depending on the route you take to achieve your desired dimensions.

posing as potential clients have reported that some programs use high-pressure sales tactics, fail to consider individuals' unique medical needs, and deliberately confuse clients with complicated pricing systems. Some people sign up for a program and only realize partway through that the promised results are only "guaranteed' if they buy thousands of dollars' worth of special food or supplements. Others feel so defeated when they're unable to lose the weight that they blame themselves or are too embarrassed about being ripped off to lodge a complaint.

Independent experts—which includes doctors and nutritionists who aren't making money off weight-loss schemes—almost all agree: any plan that promises fast weight loss and recommends something other than a balanced approach to nutrition and regular exercise is likely to be a fraudulent fad.

The same principles hold true for products promoted in gyms and sold in sports stores promising weight gain. Few, if any, of these produce the kind of results shown in magazine ads, which rarely tell the whole truth. Some bodies are simply designed to build up muscles more easily than others, and the photos tend to feature guys who not only have the right physique but also invest countless hours in the gym. Then comes the airbrushing!

UN-REALITY PROGRAMMING

BEAUTY MAKEOVERS HAVE BEEN A STAPLE of women's magazines for decades. Readers have always been fascinated by the kind of real-life Cinderella stories that makeovers represent. We get vicarious satisfaction out of watching a person being transformed from a caterpillar into a butterfly. Seeing becomes believing: if they did it, we think, so can we. We fantasize about what it would be like to eliminate our own imperfections.

These days, reality television has pushed the makeover phenomenon to a whole new level. Where magazines changed people's hairstyles, makeup, and clothing, TV shows like *Extreme Makeover*

and *The Swan* are offering much more invasive procedures like orthodontic work, face-lifts, and breast implants.

The participants in the shows are often grateful to be on the receiving end of such expensive transformations, which can cost as much as $72,000. Lori Floyd says that before her makeover, a weak chin and hooked nose made her really stand out; she went so far as to quit high school because of her depression. Now she says it feels great to "just blend in."

Extreme Makeover lives up to its name: in some cases, the participants have so much work done, they emerge from the process looking like completely different people. Tammy Guthrie, a Florida woman, was given a face-lift, eye-lift, brow-lift, nose job, collagen injections, and facial resurfacing. She says that when she was first "revealed"—the show stages an elaborate party to unveil each person's new look—her four-year-old son said, "That's not my mommy." She says, "My heart just sank when I heard that." Her husband's reaction was also upsetting. "I kept saying, 'What do you think?' And he would say, 'Well, you definitely look different.'"

Another participant in the show, Kine Corder, is happy she underwent the makeover, but still has mixed feelings about its impact. "Now guys say things like, 'Oh, I fell in love with you as soon as you walked in the room.' And I'm like, Yeah, right. Was it the boob lift? The lip reduction?"

If the media play a role in profiling the difference that plastic surgery can make, they also play a role in creating the perceived need for it. It's a bit of a vicious circle. When we read magazines and watch television, many of the most prominent images we see of models and actors have been altered into a state of idealized perfection. We've become conditioned to see real human bodies—our own and others—as much less attractive in comparison.

In fact, research has found that the more exaggerated the bodies are, the more negative their impact on viewers' self-esteem.

Looking at untouched photos featuring good-looking women whose bodies haven't been surgically altered doesn't undermine women's confidence nearly as much as looking at graphically enhanced images of surgically altered or exceptionally thin models.

In other words, the more people have plastic surgery, the lousier those who haven't had it are likely to feel about themselves.

ADDICTED TO THE KNIFE

JAMIE LEE CURTIS may have sworn off rejuvenating procedures and Jennifer Lopez may insist that she'll never go under the knife, but many of their entertainment industry colleagues have bought into the need to make regular visits to their cosmetic surgeon.

One of the costs of being a Hollywood star is the pressure to keep up appearances. The entertainment industry is harsh when it comes to judging people by their looks, and many insiders have said that if actors—especially females—don't have "work" done, they stop getting hired.

The changing appearances of many performers suggest that the practice is widespread at all ages. Alterations to the faces of Hollywood stars like Lara Flynn Boyle and Helen Hunt have fueled speculation about the "work" they've had done. And while she was still in her teens,

STACKING THE DECK

Have you ever noticed that both the print and broadcast-sponsored makeovers have a tendency to stack the deck to make the transformations appear even more dramatic than they really are? Some elements of a makeover can, of course, achieve amazing results. But the before and after pictures are usually carefully crafted to exaggerate the differences. Looking at the before images, don't you sometimes want to shout, "Never mind the plastic surgery: just brush your hair, stand up straight, and smile!"

The "before" photos are often shot under fluorescent light or outside. The person wears casual clothes and no makeup, refrains from smiling, and often appears slumped, with unwashed hair.

In contrast, the "after" photos are taken with the aid of studio lights and colored gels, which improve skin tone. In addition to having had their hair and makeup professionally done, the makeover subjects are wearing fancy evening clothes and a brilliant smile.

No wonder they look transformed!

Britney Spears' suddenly enhanced bosom generated all sorts of breast implant rumors.

Michael Jackson has reportedly undergone as many as 50 surgical procedures, and although his case is an extreme one, multiple operations are increasingly common. This is partly due to the temporary nature of most procedures. While rhinoplasty may change the shape of a nose forever, Botox injections only last a few months and liposuction often has to be repeated if the person gains weight. Even the effects of face-lifts last only 5 to 10 years, and problems with breast implants frequently require follow-up surgery, before they, too, are eventually replaced.

Pop and movie stars aren't the only ones affected by this. The American Society of Plastic Surgeons reports that 37 percent of Americans who had a cosmetic procedure in 2002 were repeat customers. It's as if once you get on the treadmill of trying to turn back the impact of aging, or create the perfect profile, you can never get off. And the habit's awfully expensive.

IMAGE REFLECTIONS

AS MORE AND MORE NORTH AMERICANS choose radical means of changing their appearances, it starts to seem like a normal thing to do. Now people are beginning to ask, where will it stop? Will drastic dieting, monthly injections, plastic surgery, or regular makeovers become as commonplace as twice-yearly dental check-ups? If so, will Hollywood-style good looks eventually become

so ordinary that we'll lose interest in beauty? Maybe our definitions of what's stunning will simply change to embrace appearances that are rare and unusual.

Who knows? It's also possible that people will decide the physical and financial costs of these practices outweigh the benefits, and they'll gradually disappear. In the meantime, it's good to keep honing your critical thinking skills so you can apply them to all the promises being made by cosmetics companies—the explicit ones made with words, and the ones merely implied by images.

SEND IN THE CLONES

In the past few decades, Venezuela has developed a reputation for producing more than its share of international beauty queens. But research has revealed that the success rate of the country's beauty contestants had been artificially inflated—in more ways than one.

It seems that virtually every serious contender for Venezuelan beauty crowns over a period of years had been "polished" by businessman Osmel Sousa. He and his spotters identified young women—"rough stones," he called them—in shopping malls and at dance clubs months in advance of the beauty pageants. Then a team of cosmetic and dental surgeons went to work, "fixing" their noses, chins, breasts, eyebrows, and teeth in preparation for the upcoming contests.

***** Nobody's going to paste this up on a billboard, so you just have to remind yourself: Not even supermodels look like supermodels! They're a fiction—a creation of lighting, makeup, computer graphics, and often surgery.

***** Many of the companies trying to separate you from your money are willing to stretch the truth in order to do so; if the claims being made sound far-fetched, they probably are.

***** Cosmetic surgery can make a big difference to people's appearance, but it's very expensive, requires ongoing investment, and isn't going to solve underlying emotional or psychological problems.

A DAY IN THE LIFE

Julia Roberts "hates" her "gummy smile," Hollywood colleague Susan Sarandon went through high school squinting because she was so self-conscious about her large eyes, and in reference to her attention-getting breasts, singer Samantha Fox says, "There are many occasions when I'd happily swap them for something smaller."

But even though the certifiably hot express such dissatisfaction, it doesn't stop many of the rest of us from fantasizing about trading in a few of our own features for their camera-ready ones.

DREAM COME TRUE?

SO LET'S SAY YOU WAKE UP ONE MORNING and suddenly you're inexplicably beautiful. Right on, you think; all my problems are over!

You hardly know where to start in enjoying your new, exciting life. In the bathroom, you can't drag yourself away from the mirror, the buzz you're getting from gazing at your exquisite face is so great. Finally, you realize that pesky banging noise is your brother, who's been waiting to use the washroom and is now shouting, "Okay, Narcissus—that's enough for one day!"

As you get dressed, you discover the simple truth that when you're gorgeous, it doesn't really matter what you wear, because you look great in everything.

By the time you reach school, you feel like the most powerful person on Earth. You strut down the hall to your locker, smiling generously at everyone. You bask in the glow of their admiring glances. They seem honored when you bless them with a "hi" or "how's it hangin'?" Life is sweet.

Are good-looking kids a lot happier than everyone else? Not always, as it turns out: appearances can be deceiving.

At lunchtime, the table you usually sit at with a couple of your friends is surprisingly crowded with good-looking kids from your grade. And they all seem to be openly flirting with you. You find yourself responding with wit and intelligence. Everything you say is clever and entertaining. All around you, people are having a great time.

That afternoon, sitting in English, you start daydreaming about the new careers that are open to you now. Will you go to Hollywood, or try to make it in New York? Will you pursue a career in movies, or start with music? Will you...

REALITY CHECK

OKAY, YOUR FANTASIES ABOUT LOOKING GREAT may be different: they may involve simpler dreams of being zit-free and five inches taller, or having straight hair and a smaller nose. But let's

skip the dreams and move to reality: let's hear from some people whose appearances have been judged worthy of magazine covers.

Remember Brooke Shields? Most recently she had her own TV series, and for years she was regularly featured in the celebrity press, both because of her own supermodel profile and the international fame of her former-fiancé, tennis star Andre Agassiz.

Brooke became a model and movie star in her early teens. With thick dark hair, strong even features, and a tall slim build, she was beautiful enough to be plucked from obscurity and vaulted to fame by the one-time king of provocative billboard campaigns, Calvin Klein. She first appeared discreetly topless (you couldn't actually see her breasts) in prominent ads. The accompanying headline, "Nothing comes between me and my Calvins," was obviously designed to get you thinking about the fact that, other than the jeans, she was naked. Then she was cast in a couple of popular teen-oriented movies that also presented her in very sexual roles. She became her generation's "it" girl, and the object of teenage boys' fantasies.

Does it sound like a dream come true?

Brooke Shields' memories of high school tell a different story. She recalls that all she wanted as a teen was to be accepted by her peers, but she was ostracized because of her fame. No one would sit with her at the lunch table, and she felt as if she were constantly under scrutiny.

She didn't even enjoy the advantages that you might imagine accompanied her model good looks. Instead, she remembers spending as much time as her peers did looking at fashion magazines and wishing that she looked like Cindy Crawford or Stephanie Seymour!

Doesn't sound like she was any more comfortable with her appearance than anybody else, does it? If you read enough celebrity interviews, it becomes clear that lots of stars are insecure about their looks. Does that mean it's a natural part of being human, or do you think they just hold themselves to a higher

standard of perfection because of the business they're in?

GLAMOR GIRLS

THE BEAUTY SPECS that appear on Morgan's modeling comp sheet describe her as 5'10" tall, with dark blonde hair and blue eyes and bust, waist, and hip measurements of 34-25-35. She wears a 4–6 size dress. But the professional photographs that make up the comp sheet tell an even more compelling story: they feature a young woman who could be a cross between Gwyneth Paltrow, Sarah Polley, and Uma Thurman.

PERFECTION IMPOSSIBLE

Hollywood director Joel Schumacher has worked with Demi Moore, Julia Roberts, and Sandra Bullock, among many others. But he says, "I have never worked with a beautiful young woman who thought she was a) beautiful, or b) thin enough."

For her part, Julia Roberts thinks the pressure has intensified even in the years since she starred in *Pretty Woman*. "I couldn't be an *ingenue* today," she says, "because the business has changed. I remember when you could dress for a premiere just by putting on a cute top. Now you have to be perfect and fabulous in every way, or you're ridiculed."

In junior high school, Morgan recalls being shy and reserved, and not especially popular with boys, many of whom she towered over. But when a model acquaintance urged her to show up at the local office of a big modeling agency, they immediately suggested she enroll in a $1,000 personal development course. Morgan and her parents were skeptical; some agencies are known to bulk up their bank accounts by falsely encouraging kids who don't have a hope of ever becoming professional to spend thousands of dollars on training. But the agency insisted that Morgan had the right raw material, and so her parents floated half the fee to sign her up.

"The course was pretty cheesy," she says now, but she got work immediately afterward, and by the end of the following year her new career had taken her to Paris, London, New York, Taiwan, Miami, Los Angeles, and Japan—not bad for a 16-year-old.

On the other hand, schlepping a portfolio of photographs around from auditions in one end of some foreign city to another

has its drawbacks. It's a lot more glamorous than flipping burgers at McDonalds, but it can be equally tiring, much lonelier, and sometimes demoralizing.

Morgan says an audition can attract as many as 80 girls, and typically involves waiting around for up to two hours. Eventually, the potential clients would look her up and down while she stood in front of them, check out her photos, and maybe ask her to walk for them. And then she'd find herself back out on the street trying to figure out how to get to the next audition, despite not knowing how to speak Japanese!

If she was lucky, after a week or two of auditions, she'd start to get work. But in the modeling business, you often just don't have the look they're after and there's nothing you can do about it. The challenge then becomes paying back the money that your agency has spent flying you to the foreign country and putting you up in an apartment. Morgan knows some girls who ended up in hock to their agencies for as much as $16,000. Under such circumstances, she says, "It can be hard to get ahead."

Agata, who has dark wavy hair, gorgeous eyes, and luminous skin, was beautiful enough to be "discovered" by a modeling agent walking down the street. But she was immediately told that she'd have to lose weight in order to be successful. Although she was of normal weight at the time, she dutifully starved herself in order to fit the waif-thin image and get work.

"It was a very delicate balance," she says. "There were times when I felt very powerful because there's such a reverence in our culture for models and if you tell people you're going off to Paris for a shoot, their eyes really light up."

But she found the work physically, emotionally, and psychologically demanding. "You're really just a commodity. You've got the stylist, the makeup and hair people and you're really just sitting there wondering when is this going to be over.... And there are days when it takes four or five hours to take *one* picture."

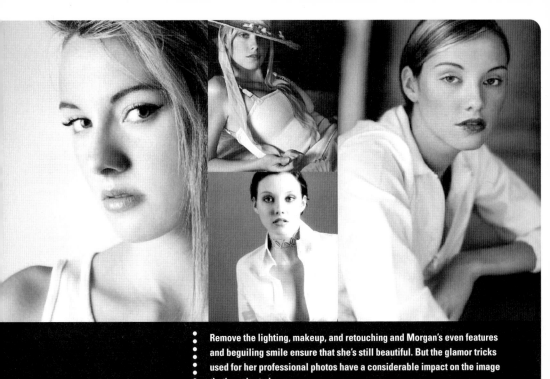

Remove the lighting, makeup, and retouching and Morgan's even features and beguiling smile ensure that she's still beautiful. But the glamor tricks used for her professional photos have a considerable impact on the image that's projected.

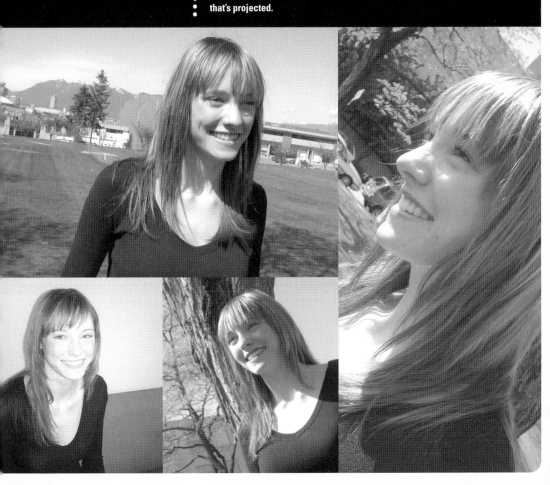

The other thing that she found difficult was having complete strangers pick apart her face and body while she was standing right there listening to them list her faults. "It really started to chip away at my self-esteem," she says. "At one moment you would be told, 'Oh, look at these pictures, you're so beautiful' and in the next, you would be told, 'You'd be so much *more* beautiful if you could lose 10 more pounds.'"

She says she stopped modeling after a few years, "Because I really felt myself dying as a person. I was constantly hungry and it became the center of my life. I was unable to derive any pleasure from being in Paris or Germany, because it was this constant obsession with being thin, with not eating. I was miserable." Now building a successful career in another field, she's much happier and healthier, and has no regrets about abandoning the fashion industry and getting to live a normal life.

Morgan's experience has been much better. She hasn't had to resort to drastic weight control measures, although she confesses to watching what she eats, and says her waist measurement is "borderline acceptable," even though it's only 25 inches!

Nevertheless, she says, "Modeling gave me a huge confidence boost." She describes the environment as being "sink or swim" and says learning how to survive independently helped her to become more outgoing and comfortable in social situations than she had been in her early teens. She also thinks that her appearance has helped her to get non-modeling work, even when she didn't really have any relevant qualifications.

At the same time, her looks have been a hindrance. At one job, some of her female colleagues seemed to resent that she got a lot of attention, that guys were always stopping at her desk to talk to her, and this made things difficult and awkward.

But she's not inclined to complain, and she's realistic about the limitations imposed by the beauty business itself. Although she continues to model today to help pay her bills, those bills include

university fees so that she has other options when her youth and beauty run out. As Morgan points out, most models are considered over the hill by the age of 27.

"Even 24 is too old," she says. "I've had to lie about my age and say I was 21 in order to be considered for some jobs." Faces on fashion magazines, in particular, she notes, are almost always younger. "If you're not a superstar by the time you're 26, you can forget it," she says. It won't happen.

Like Agata, she has no regrets about not having achieved that stratosphere herself. "Modeling doesn't fulfill me enough as a career. It's not stimulating mentally and you don't have any personal impact through what you're doing."

PLAYING THE "BOY TOY"

IN PERSON, ELIA IS FRIENDLY, open, and professional. When he's talking animatedly about his experiences and perceptions and inquiring about your own, it feels like you're shooting the breeze with the down-to-earth, really nice-looking guy next door.

But then he pulls out some of his modeling photographs, and you suddenly wonder how you ever came to be sitting in a donut shop with this living, breathing Adonis. In the photos, he looks unreachable and intimidating; his hair is perfect, the expression on his handsome face is somber, his dark eyes gaze off into the distance, and his beautifully defined arms, abs, and shoulders look like something out of, well, a magazine ad.

He points to a picture of himself taken on the set of a teen TV series he starred in. He's wearing little more than a tool belt and he looks like a poster boy for the best diet and exercise program in the world. "It takes a lot of work," he says, describing the years of weight training he did from the age of 17 to build himself up to 200 pounds—to add a lot of bulk to his 5'10" frame. But like Agata, when he started modeling, he was immediately told to lose 40 pounds. So he overdosed on exercise and went on crazy diets,

cutting out fats and carbohydrates completely, until he literally couldn't think straight and his hair started to fall out.

Eventually, he smartened up, sought professional help and took a slower approach. Now he's about 170 pounds, but controlling his weight remains a constant preoccupation. "I'm very conscious of everything I eat, everything I do that affects my body." To maintain his impressive "six-pack" and a profile slim enough to keep him in work, he has eliminated sugar, dairy products, and bread from his daily diet. He confesses to eating turkey and gravy at Thanksgiving, but still shuns the mashed potatoes and pie.

Such an extreme approach is necessary in the modeling industry, he says: "You're a piece of meat. You go to an audition and there might be 50 other beautiful people there. So you don't stand out. It's very competitive. And that's why models are the most insecure people on the planet. Someone is always telling you how good-looking you are, but then you get cut down for having fat legs, even though you're actually anorexic. It really messes with

your mind. You look in the mirror, and you don't actually see what's really there. And no matter how good you get physically, it's not good enough for the people hiring you."

On the other hand, he readily admits that his appearance is an asset in other areas of his life. He owns and operates a small video-production business and he finds people often go out of their way for him, or are just more inclined to hire him because of his looks.

He also suspects he was cast in the TV series solely on that basis, and he feels badly about it. "Once I started studying acting and realized what was involved in it, I didn't think I deserved the success."

FAIR FRIENDS AND DREAM DATES

As MUCH AS ELIA APPRECIATES the advantages his appearance brings him, on a personal level it also creates challenges. "People are intimidated by me. I get a lot of cold shoulders from guys, treated like I'm a jerk for no reason. And in social situations, girls my age often won't talk to me. They assume I'm full of myself, and they won't even bother trying to get to know me."

On occasions when he has begun to develop a relationship with a girl he likes, some of his male friends have given him a hard time. "They've said, 'You can do so much better than that'; they judge the girls on a really superficial level."

Such assessments affect pretty girls, too, notes Morgan. "Some people assume that you're not very intelligent and are surprised when you turn out to be smart or nice." She's also been told that she intimidates people and has often found it "easier to make guy friends—although then sometimes their girlfriends get jealous, even though we really are just friends."

HAPPINESS NOT GUARANTEED

ALTHOUGH IT MIGHT SEEM OTHERWISE, being gorgeous has little bearing on whether or not you'll live "happily ever after." Consider

the evidence provided by the life of actress Elizabeth Taylor. In the 1950s and '60s, she was believed by many to be among the most beautiful women in her generation and beyond. Yet she's been married seven times.

> Just because you're seen as beautiful by the masses doesn't mean you're happier than them, or your world is better, or you don't have the same problems. I never try to sell an image that I'm always happy. I've gone through traumas... just like everyone else.
>
> —actor Cameron Diaz

And she's not alone in her ongoing quest for elusive bliss. Hollywood gossip rags and entertainment TV shows are full of gorgeous stars who are suffering from not just derailed relationships but serious drug addictions and emotional breakdowns.

Halle Berry may hover around the top of the world's most beautiful women list, but her life hasn't exactly been a picnic: she's survived an alcoholic father, abusive relationship, bitter divorce, serious car accident, suicide attempt, and unfaithful husband.

Beauty—even when it's accompanied by fame and fortune—is no guarantee that things will always go your way.

PERFORMANCE PRESSURE

ISN'T IT GREAT TO HANG OUT with family or close friends, without having to worry about what you're wearing or how you look? Well, sometimes being gorgeous—and caring about it—means you have to kiss that good-bye.

If the way people relate to you is mostly shaped by how hot you look, keeping up that appearance can become a necessary chore. It's like being a basketball star or straight-A student: once you've established that you're good at something, and people expect it

of you, you feel pressure to maintain the illusion that you're perfect.

For those whose income is dependent on a buff body and flawless face, the concern is a legitimate one: supermarket tabloids are full of candid photos of stars in various states of imperfection. If they go out of the house with a baseball cap on over their unwashed hair and sunglasses designed to hide the fact that they haven't slept well, chances are some paparazzi is going to snap their picture and sell it to the world.

INTRODUCING THE MAKE-*UNDER*

A 22-year-old Texas woman cut her waist-length blonde hair, dyed it black, and deliberately put on 30 pounds—all to avoid the relentless stares and unwanted come-ons that greeted her every time she went out in public.

Another woman from New York quit the modeling business because she got tired of men assuming that she would "just jump into bed with them." She said the attention her looks brought her was "not necessarily the kind you want."

These fashion models from the 1920s look more representative of the average woman than the models who grace the covers of most women's magazines today.

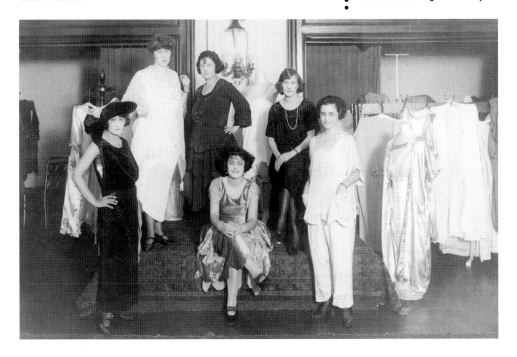

Of course, many people who aren't exceptionally good-looking feel the same attachment to putting their best face forward, whether they're going to buy bread or attend a formal event.

THE DARK SIDE

THE POWER OF BEAUTY may buy those who have it all sorts of privileges and opportunities, but like any kind of power, it's open to abuse. There's nothing to stop people who are beautiful, or those who want to be close to it, from manipulating others or giving in to risky temptations that get them into trouble.

Morgan has witnessed aspects of the dark side of the beauty industry and notes that "You can get away with a lot more when you're beautiful. It's pretty easy to use the way you look to get into places, to get what you want."

She describes the kind of atmosphere that's common on the modeling circuit, where agencies put up their models in special apartments in New York or London while they're in town for auditions or shoots. Party promoters regularly call up the apartments and invite whoever is staying there out to restaurants and clubs. They buy the models dinner, booze, and sometimes drugs, and give them access to VIP areas where they get to meet famous people—all in the hope that the models' presence will attract more customers to the bars and restaurants. For young models especially, the attention and privileges can be very seductive, and ultimately lead to further "power exchanges" that get them into trouble.

Says Morgan, "I saw lots

A DIFFERENT KIND OF HOMEWORK...

Nikki Reed, who co-wrote and starred in the movie *Thirteen*, recalls that when she was in grade seven, she and a girlfriend used to get up at 4:30 in the morning in order to get ready for school. They'd spend up to three hours a day fixing their hair and makeup, and keep a detailed list of what they wore each day so as not to ever wear the same thing twice. You have to wonder if anyone would have noticed if they'd slipped up, lost track, and repeated themselves!

of girls who attracted really rich boyfriends, who took them away on trips all the time, and bought them expensive presents. But there are always expectations that come with that. Nothing really comes for free, usually they want something from you in return."

Although many models keep their heads on straight and avoid getting caught up in destructive relationships or habits, the industry is rife with stories of drug addiction and sexual exploitation.

For his part, Elia says that because of his appearance, "It's easy to meet and pick women up in the bar, to take them home. I have a friend who's always encouraging me to exploit my looks. I could live a very different lifestyle than I do, but that's just not who I am."

Like many female models, Elia frequently gets hit on by photographers who try to cajole him into taking off all of his clothes. Although he hasn't ever felt physically threatened by such situations, they make him uncomfortable enough that he recently turned down the opportunity to appear in a major catalogue known for its especially risqué photo features.

IMAGE REFLECTIONS

OKAY, SO GORGEOUS PEOPLE don't exactly have it made. Living off your good looks can inspire yawns, certifiably cute star Drew Barrymore thinks she has legs like a corgi, and even heartthrobs like Justin Timberlake suffer heartbreaks, just like everyone else.

Knowing this stuff may not stop us from longing to look a little more like Jessica Alba or Josh Hartnett, but when you're feeling frustrated with your imperfections, it might help to remember that a) perfection doesn't actually exist, and b) even being close is no guarantee of happiness.

* What looks incredibly glamorous from the outside can be unfulfilling or very difficult from the inside.

* It's hard to make it in the beauty biz long-term without giving in to the pressure of making health-threatening sacrifices.
* Who knew? The intimidation lots of people feel in the presence of someone who's especially hot means beautiful people sometimes have difficulty forming relationships.
* The stress of keeping up appearances probably weighs heavier on people whose relationships (professional or personal) are more dependent on appearance in the first place.

What
Sarah
Sees

What
everyone
else
Sees

BEYOND IMAGE

You are not your nose. Or your butt, or the cold sore on your upper lip. You are not your hair—on good or bad days. You are not your legs or your lips or the mole that only you (and possibly your mother) know about. You are not your biceps or your fingernails.

And when people look at you, none of them see you the way you see your reflection in the mirror. Unlike you, they're not distracted by that little voice nattering away in your head. You know, the one that's constantly encouraging you to do things you shouldn't. Like obsess about how much hotter you'd look if you lost—or gained—10 pounds, or how unfair it is that your brother got long legs *and* thick hair.

No, when people look at you, a lot of the time they're too pre-occupied by the unconscious commentary of their *own* destructive alter ego to even register the zit on your forehead, or the way one of your front teeth slightly overlaps another. Nine times out of ten, their inner dialogue is way more focused on whether or not *they're* measuring up than whether or not you are.

Really.

TAKE A BEAUTY BREAK

IT'S NOT EASY TO ESCAPE the beauty messages of the world we live in. Too many of the businesses that support most entertainment media are all about turning your appearance insecurities into their profits. They know that the greater the difference between the good looks of the people they show you and your own, the more likely you are to run out to buy stuff.

Psychologists call this "discrepancy theory," and the formula is a proven one. But that doesn't mean it's inescapable. And the solution is refreshingly inexpensive. When what feels like the relentless onslaught of idealized perfection is getting you down, give yourself a beauty break: toss the fashion mag, turn off the TV, take a pass on the mall. Call a friend, listen to music, go outside.

The truth is, media junkies are more likely to worry about their appearance or suffer poor self-esteem than people who are too busy actually *doing* stuff to spend much time just watching.

A number of studies have found that the less time people spend watching TV and reading consumer magazines, the greater the chances are that they'll feel good about their appearance.

EXPAND THE DEFINITION

LOOK UP "BEAUTY" IN THE DICTIONARY: It defines the word as "the combination of all the qualities of a person or thing that delight the senses and please the mind."

Combination. Not *one* single feature. Not solely visual appeal.

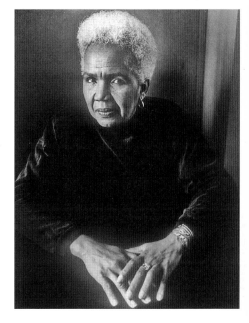

Born in Jamaica, Rosemary Brown was a human rights activist, university professor, mother, and elected official. Her beauty—as evident at 75 as it was at 25—was enhanced by her strength, intelligence, and sense of humor.

But the sum total of a person's qualities. Both the ones that delight the senses—including sound, smell, touch, and taste, as well as sight—and the ones that please the mind—whether that be with intelligence, humor, generosity, or grace.

Well, you might think, isn't that confusing beauty with attraction? Yeah, probably; so what? Why do any of us want to be beautiful? Mostly so that other people will think we are. And given that we only have so much control over the way we look, and the competitive field keeps getting more and more crowded all the time, what could be wrong with enhancing our attractiveness by focusing a little attention elsewhere?

THE TRIUMPH OF PERSONALITY

CONSIDER THIS: in 2001 Clairol commissioned an independent survey of Americans' attitudes on female beauty and discovered that:

* Both women and men who responded said that the element of personality is the most important aspect of a person's attractiveness.
* For men, the chief component of personality was sense of humor.
* Women cited compassion as the most important personality factor.
* The most crucial physical feature for guys was eyes.
* For women, a great smile topped the list.

The role of personality in beauty is difficult to measure, but its impact is supported by research. In addition to the fact that sense of humor scores high on the list of things many people find attractive, those who laugh and smile a lot (as opposed to frown and scowl) end up with better-looking facial lines.

Are you still skeptical? Do you think people say one thing when they respond to polls, but actually behave differently in real life? Lots of other research supports the importance of personality in who we're attracted to. For instance, even though guys typically have higher expectations of women's appearance than girls do of guys', one experiment found that men are more inclined *not* to notice a woman's physical imperfections if she's got a great personality.

Who you are really *can* alter what you look like. Research has found that beautiful people with disagreeable personalities become less and less attractive over time. This is partly because as we age, repeated facial expressions create lines and wrinkles. People who frequently smile and laugh end up having more attractive lines than those who scowl and vent a lot of anger. In another study, the women who had been outgoing as teens were judged to be

better-looking in their fifties than their snobby, unfriendly peers, regardless of who was considered hot stuff in high school.

Former First Lady Eleanor Roosevelt noticed this, even without the benefit of research. She once said that beautiful young people are accidents of nature, but beautiful old people are works of art.

Even if you don't think your genes put you in the "beautiful accident" category, it wouldn't hurt to cultivate personal charisma, as well as clear skin. Made up of a combination of sometimes indefinable qualities, it can more than compensate for a lack of physical "wow" factors.

Marlene Dietrich may have said it best. The 1930s film star claimed that, "The average man is more interested in a woman who is interested in him than he is in a woman, *any* woman, with beautiful legs."

Sight Unseen

Many people can become completely captivated by someone they've only ever spoken to over the phone, or heard on the radio. Voices are almost as distinctive as fingerprints, and regardless of what words are spoken, can embody many appealing qualities: emotional empathy, intelligence, enthusiasm, a sense of humor, excitement...

Research shows that when we hear an attractive voice, we often assume the person speaking is physically appealing, likable, and

YOU THINK YOU'VE GOT PROBLEMS?

James Partridge was severely burned in a car fire at the age of 18 and suffered terrible scarring that really repelled people.

But over time, even though his physical appearance didn't change, he found that the scarring wasn't as much of a problem.

"I think it had to do with the coping skills I developed," he says. He persevered in building up his self-confidence, cultivating his personality so that it became more noticeable than the superficial texture of his skin. Happily married, he now earns his living helping others overcome their own beauty handicaps by enhancing their personality resources.

competent. But a good-looking person with a squawking voice will come across as less attractive. In recognition of this, supermodels Cindy Crawford, Linda Evangelista, and Paulina Porizkova have reportedly all invested in lessons to lower the pitch of their voices.

TUUM EST

... IS A LATIN PHRASE MEANING "IT'S UP TO YOU."

Long before Nike turned "Just Do It" into an exercise mantra, or "go for it" became a common expression of encouragement, *tuum est* embodied the notion of free choice, underlining the fact that you get to decide: What you think about, whom you admire, how you use your time, where you spend your money, what you do with the assets you've got. And which messages you buy into about what's beautiful.

And the most important question of all might be: do you invest energy in being critical of yourself—your face, your body, your hair—or do you find ways to break free of media ideals instead?

The choice is yours. And every day, in dozens of small ways, you get to choose: you can wear eyeliner or go natural. Give up french fries or take the stairs. Master the guitar or watch TV. Pump iron or go for a run. Read a book or scan the magazines. Fret over your flaws or not.

Some choices are more likely to put a smile on your face than others. To make you feel good about who you are and what you can do in the world. To help you focus on *being,* instead of just *appearing* to be.

Tuum est.

NOTES

CHAPTER 1: ONCE UPON A TIME...

Tomb of an Egyptian nobleman. Cathy Newman, "The Enigma of Beauty," *National Geographic,* January 2000.

The Paper Bag Princess. Robert N. Munsch, *The Paper Bag Princess* (Toronto: Annick Press, 1980).

Greek gods and goddesses. Robert E. Bell, *Women of Classical Mythology: A Biographical Dictionary* (New York: Oxford University Press, 1991), 53–56; and *Mythologica: A Treasury of World Myths and Legends* (Vancouver: Raincoast Books, 2003), 56–75.

CHAPTER 2: THE EYE OF THE BEHOLDER

measuring beauty. L.G. Farkas and I.R. Munro, eds., "The Validity of Neoclassical Facial Proportion Canons," *Anthropometric Facial Proportions in Medicine* (Springfield, IL.: Charles C. Thomas, 1987), 57–66.

Peter Paul Rubens. *Theory of the Human Figure,* 1620, as cited in Arthur Marwick, *Beauty in History* (London: Thames and Hudson, London, 1988), 444.

hair lore. Nancy Etcoff, *Survival of the Prettiest: The Science of Beauty* (New York: Doubleday, 1999), 121–27; Norman Rockwell, *My Adventures As an Illustrator* (Garden City, NY: Doubleday, 1960), 201–4.

spiritual tresses. Laura Brooks, *Traveling the Spiritual Path: The Struggle for Native American Religious Freedom,* www.dickshovel.com/nar/html; www.canteach.ca/elementary/sikhism8.html

Julia Roberts. "No-shave zone is sexy," *London Sunday Times,* 30 May 1999.

Marilyn Monroe. www.snopes.com/movies/actors/mmdress.htm

curves ahead. Joan Jacobs Brumberg, *The Body Project: An Intimate History of American Girls* (New York: Random House, 1997), 99109; Kate Mulvey and Melissa Richards, *Decades of Beauty: The Changing Image of Women 1890s–1990s* (New York: Hamlyn, Octopus Publishing Group, 1998), 16–200; "Fashion and Style", *The Readers Companion to World History,* Houghton-Mifflin, http://college.hmco.com/history/readerscomp/rcah/html/ah_030000_fashionandst.htm; Roberta Pollack Seid, *Never Too Thin: Why Women Are at War with Their Bodies* (New York: Prentice Hall, 1989), 72–81; Terry Poulton, *No Fat Chicks: How Woman Are Brainwashed To Hate Their Bodies and Spend Their Money* (Toronto: Key Porter, 1996), 48.

Twiggy. *New York Times,* 20 March 1967.

body image goes global. Lindy Sholes, "Society's Body Image: Perfect or Warped? Cultures View 'Ideal Beauty' Differently," *University of Southern Mississippi The Student Printz,* 18 July 2003 (reporting on perspectives voiced in a panel discussion); Cathy Newman, "The Enigma of Beauty," *National Geographic,* January 2000; Julian Robinson, *The Quest for Human Beauty: An Illustrated History* (New York: W.W. Norton, 1998), 37, 85; Ian Fisher, "Kampala Journal; Rating Beauty with a Tape Measure, Inch by Inch," *New York Times,* 22 May 2001.

Fiji eating disorders. Newman, "The Enigma of Beauty."

dog-eyed westerners. Etcoff, *Survival of the Prettiest,* 134–45; Robinson, *The Quest for Human Beauty,* 21, 83.

teenagers around the world. Robinson, *The Quest for Human Beauty,* 23.

Frank Toskan. Dorothy Schefer, *What Is Beauty: Nouvelles Définitions* (Paris: Editions Assouline, 1997), 13.

diversity. Ruth La Ferla, "Generation EA: Ethnically Ambiguous," *New York Times,* 28 December 2003.

CHAPTER 3: THE YOUNG AND THE HEALTHY

psychologist quote. Cathy Newman, "The Enigma of Beauty," *National Geographic*, January 2000.

evolution, natural selection. Helen E. Fisher, *The Sex Contract: The Evolution of Human Behavior* (New York: William Morrow, 1982), 87–123; Bertjan Doosje, "Partner Preferences as a Function of Gender, Age, Political Orientation and Level of Education," *Sex Roles: A Journal of Research*, January 1999; *The Nature of Sex: Sex and the Human Animal*, PBS Nature Series (video), 1992.

light skin. Nancy Etcoff, *Survival of the Prettiest: The Science of Beauty* (New York: Doubleday, 1999), 105.

scarring. Julian Robinson, *The Quest for Human Beauty: An Illustrated History* (New York: W.W. Norton, 1998), 85.

average. J.H. Langlois and L.A. Roggman, "Attractive Faces Are Only Average," *Psychological Science* I (1990): 115–21; J.H. Koeslag, "Koinophilia Groups Sexual Creatures into Species, Promote Stasis, and Stabilizes Social Behavior," *Journal of Theoretical Biology* 144 (1990): 15–35.

10,000 people in 37 countries. David M. Buss, "Sex Differences in Human Mate Preferences: Evolutionary Hypotheses Tested in 37 Cultures," *Behavioral and Brain Sciences*, 1989, 12: 1–14 as cited in Etcoff, *Survival of the Prettiest*, 59.

CHAPTER 4: SUFFERING IS OPTIONAL

making up. *CosmoGirl* December 2003/January 2004; Cathy Horyn, "At the Beauty Counter, It's Bait, Hook and Reel Them In," *New York Times*, 17 December 2002.

words in your mouth. Kathy Peiss, *Hope in a Jar: The Making of America's Beauty Culture* (New York: Metropolitan Books, Henry Holt, 1998), 173.

ancient make-up. Nancy Etcoff, *Survival of the Prettiest: The Science of Beauty* (New York: Doubleday, 1999), 101–3; Cathy Newman, "The Enigma of Beauty," *National Geographic*, January 2000; Fort Klock Historic site, www. fortklock. com/cosmeticshygiene.htm

tattoos, scarification. Etcoff, *Survival of the Prettiest*; Julian Robinson, *The Quest for Human Beauty: An Illustrated History* (New York: W.W. Norton, 1998), 81–83, 197; Jennifer Steinhauer, "Visions: Cities; A Stud in Every Tongue, and Logo Tattoos," *New York Times*, 1 January 2000; Michael Kesterton, "Social Studies: Mondo Tattoos," *Globe and Mail*, 2 January 2004; Judy Foreman, "Taking Health Risks for the Sake of Looks," *Boston Globe*, 15 July 2003.

Cher. A. Dillon-Malone, ed. *Women on Women and on Age, Beauty, Love, Men, Marriage* (London: MacMillan, 1995), 81.

foot binding. "Adding to Women's History: First-Person Stories of Chinese Foot-Binding," press release from Northwestern University, Evanston, Illinois, 16 November 1996, www.nwu.edu; San Francisco Museum, www.sfmuseum.org/chin/foot.htm

high heels. "Fashionistas in Agony over 'Toe Cleavage' Pumps," *Wall Street Journal*, reprinted *Ottawa Citizen*, 11 August 2003; American Association of Women Podiatrists, "High Heels: High Fashion That Can Hurt Your Feet," www.aawpinc.com/news.htm; Gardiner Harris, "If Shoe Won't Fit, Fix the Foot? Popular Surgery Raises Concerns," *New York Times*, 7 December 2003, A1.

plastic surgery history. Elizabeth Haiken, *Venus Envy: A History of Plastic Surgery* (Baltimore: Johns Hopkins University Press, 1997), 1–49; Sander L. Gilman, *Making the Body Beautiful: A Cultural History of Aesthetic Surgery* (Princeton: Princeton University Press, 1999), 3–118, 152-177.

liposuction. W.A. Nolen, "Fat Vacuuming: How Safe Is It?" *McCalls*, January 1984, 45–46; Ellen Meyer Schneider, "Lipoplasty Safety Guidelines Focus on Avoiding Lidocaine Toxicity, Volume Overload, Blood Clots," *Cosmetic Surgery Times*, October 2002; Susan Dominus, "The Seductress of Vanity," *New York Times*, 5 May 2002, 48.

botox and collagen. Samantha Shatzky, "New Cosmetic 'Fillers' Come from Cows and Cadavers," *Ottawa Citizen*, 10 August 2003.

breast implants. Vicki Kemper, "Desire, Caution Will Collide at Breast Implant Hearings,"
 Los Angeles Times, 13 October 2003; Staci Sturrock, "Cosmetic Surgery on the Rise for
 Teens," Cox News Service, 12 September 2003; Leslie Kaufman, "And Now, a Few More
 Words about Breasts," *New York Times*, 17 September 2000; Krista Foss and Montana
 Burnett, "The Promise of Perfection," *Globe and Mail*, 21 June 2001; Rebecca Tyrrel,
 "Iman: The Girl's Got Stones," *National Post*, 16 August 2003, SP3; Alissa Quart,
 Branded: The Buying and Selling of Teenagers (Cambridge: Perseus Publishing, 2003);
 Sharon Kirkey, "Breast Implant Study Finds 40% of Women Wanted Them Removed,"
 Ottawa Citizen, 29 October 2003; Patrick Healy, "They Got It in Surgery. Now They
 Flaunt It. Nose Jobs and Implants on the Runway," *New York Times*, 23 October 2003;
 Associated Press, "Feds to Keep Silicone Implant Ban," *New York Times*, 9 January 2004;
 Warren King, "Implants May Skew Mammograms," *Seattle Times,* 28 January 2004.
anabolic steroids. Natalie Angier, "Drugs, Sports, Body Image and G.I. Joe," *New York
 Times on the Web*, 22 Dec. 1998, www.nytimes.com; Holcomb Noble, "Steroid Use Soar-
 ing among Teen Girls," *Globe and Mail*, 1 June 1999, reprinted from *New York Times.*

CHAPTER 5: DOUBLE STANDARD
male beauty prized, dandyism, industrial revolution. Julian Robinson, *The Quest for
 Human Beauty: An Illustrated History* (New York: W.W. Norton, 1998), 44, 193, 203.
Drew Barrymore. Allison Glock, "Drew Barrymore Can Do No Wrong" *Elle Magazine*,
 January 2004.
Helena Rubenstein. Kate Mulvey and Melissa Richards, *Decades of Beauty: The Changing
 Image of Women 1890s–1990s (*New York: Hamlyn, Octopus Publishing, 1998), 207.
men act, women appear. John Berger, *Ways of Seeing* (London: BBC/Penguin Books, 1977),
 46–47.
women's magazines and men's magazines. Amy R. Malkin, "Women and Weight: Gendered
 Messages on Magazine Covers," *Sex Roles: A Journal of Research*, April 1999 (all articles
 from academic journals are available at www.findarticles.com).
15% of women would sacrifice more than five years of life. Brenda L. Spitzer, "Gender
 Differences in Population Versus Media Body Sizes: A Comparison Over Four Decades,"
 Sex Roles: A Journal of Research, April 1999.
ideal vs real. Kristen Harrison, "Television Viewers' Ideal Body Proportions: The Case of
 the Curvaceously Thin Woman," *Sex Roles: A Journal of Research*, March 2003.
casting couch woes. Gloria Steinem, *Outrageous Acts and Everyday Rebellions* (New York:
 Signet, 1986), 183; Jancee Dunn, "The Dating Game," *Rolling Stone*, July 11–25, 1996.
never mind me. *Elle Magazine*, May 2003, www.elle.com/article.asp?section_id=
 14&article_id=2363&page_number=1.
GI Joe. Natalie Angier, "Drugs, Sports, Body Image and G.I. Joe," *New York Times on the
 Web*, www.nytimes.com, 22 December 1998.
female actors' earning potential. Cecily Hunt, *How to Get Work and Make Money in
 Commercials and Modeling* (New York: Van Nostrand Reinhold, 1990), 25; Edward
 Guthmann, "Many Actresses Hitting Middle Age Find Themselves Desperate for Good
 Parts," *San Francisco Chronicle*, 15 August 2003.
men's beauty spending. Karyn Siegel-Maier, "Skincare is Just for Women, Right? Guess
 Again!" *Better Nutrition*, July 2001.

CHAPTER 6: BEAUTY POWER
Bess Myerson. Susan Dworkin, *Miss America, 1945: Bess Myerson's Own Story* (New York:
 Newmarket Press, 1999), 183, 196.
ugly laws. Sander L. Gilman, *Making the Body Beautiful: A Cultural History of Aesthetic
 Surgery* (Princeton: Princeton University Press, 1999), 24.
Irish and Jewish noses. Holly Brubach, "Beauty under the Knife," *Atlantic Monthly*,
 February 2000.
Lil' Kim. *US Weekly,* November 10, 2003 and Celebrity and Entertainment News, 1
 November 2003 (http://www.2004allstars.com/news/Entertainment/11_17_03.htm).

skin lighteners, hair products. Kathy Peiss, *Hope in a Jar: The making of America's Beauty Culture* (New York: Metropolitan Books, Henry Holt, 1998), 52.

beauty crimes. Wallace Immen, "Illegal Clinics Offer Cut-Rate Beauty at a Deadly Price," *Globe and Mail*, 25 April 2001.

size bias. R. Puhl and K.D. Brownell, "Bias Discrimination and Obesity," Yale University, New Haven, Connecticut, www.obesity.org/discrimination/employment.shtml

Tracey Gold. Jesse Lewis, "Actress Warns Against Anorexia," *Arizona Daily Wildcat*, 29 January 2004.

Karen Carpenter. www.karencarpenter.com

disordered eating. Health Communication Research Laboratory, http://hcrl.slu.edu/HCRL/Programs/TeentoTeen/Eatingdisorders/effects.html

affluenza, running shoe murders. Rick Telander, "Your Sneakers or Your Life," *Sports Illustrated*, 14 May 1990.

jeans. www.brandnamejeans.com; www.marks.com

teens' skepticism. "Targeting Kid Consumers: Tapping Teen Spending—Online," First Impressions Marketing 1999, www.fim.uk.com

cool hunt. Malcolm Gladwell, "The Cool Hunt," *The New Yorker,* 17 March 1997.

tattoos and piercings. Lester B. Mayers, Daniel A. Judelson, Barry W. Moriarity and Kenneth V. Rundell, *Prevalence of Body Art (Body Piercing and Tattooing) in University Undergraduates and Incidence of Medical Complications,* Mayo Clinic, 2002, http://www.mayo.edu/proceedings/2002/jan/7701a4.pdf

clothing laws, in Venice. Nancy Etcoff, *Survival of the Prettiest: The Science of Beauty* (NewYork: Doubleday, 1999), 218–19; in Japan. Julian Robinson, *The Quest for Human Beauty: An Illustrated History* (New York: W.W. Norton, 1998), 83.

Cornell students. Jessica Johnson, "The Primping Hour," *Globe and Mail*, 20 December 2003.

CHAPTER 7: OPPORTUNITY OR KNOCKS?

German proverb. Arthur Marwick, *Beauty in History* (London: Thames and Hudson, London, 1988), 444.

flat tire. R. Athanasiou and P. Greene, "Physical Attractiveness and Helping Behavior," *Proceedings of the 81st Annual Convention of the American Psychological Association* 8 (1973): 289–90, as cited by Nancy Etcoff, *Survival of the Prettiest: The Science of Beauty* (New York: Doubleday, 1999), 45.

more confidence. Alan Feingold, "Good-looking People Are Not What We Think," *Psychological Bulletin* 111 (1992): 304–41.

control of lives. R. Anderson, "Physical Attractiveness and Locus of Control," *Journal of Social Psychology* 105 (1978): 213–16.

more assertive. D.J. Jackson and T.L. Huston, "Physical Attractiveness and Assertiveness," *Journal of Social Psychology* 96 (1975): 79–84.

assumptions. interview with psychologist Ellen Berscheid, "America's Obsession with Beautiful People" *U.S. News and World Report*, 11 January 1987.

guilty. R. Mazzella and A. Feingold, "The Effects of Physical Attractiveness, Race, Socioeconomic Status, and Gender of Defendants and Victims on Judgments of Mock Jurors: A Meta-Aanalysis," *Journal of Applied Social Psychology* 24 (1994): 1315–44.

bad behavior. K.K. Dion, "Physical Attractiveness and Evaluation of Children's Transgressions," *Journal of Personality and Social Psychology* 24 (1972): 207–13.

women and men on the phone. M. Snyder, E.D. Tanke, and E. Berscheid, "Social Perception and Interpersonal Behavior: On the Self-fulfilling Nature of Social Stereotypes," *Journal of Personality and Social Psychology* 24 (1972): 285–90.

beauty in the workplace. Daniel S. Hamermesh and Jeff E. Biddle, "Beauty and the Labor Market," National Bureau of Economic Research, November 1993; "The Right to Be Beautiful," *Economist* 367 (24 May 2003): 9; P. Douglas Filaroski, "Tall People Get Perks on the Job," *Jacksonville Business Journal*, 17 October 2003.

bottom line on beauty advantages. Nancy Etcoff, *Survival of the Prettiest: The Science of Beauty* (New York: Doubleday, 1999), 50.

beauty and integrity. A.H. Eagly, R.D. Ashmore, M.G. Makhijani, and L.C. Longo, "What Is Beautiful Is Good, But...: A Meta-Analytic Review of Research on the Physical Attractiveness Stereotype," *Psychological Bulletin* 110 (1991): 109–28.

being asked to help. A. Naadler, R. Phapira, and S. Ben-Itzhak, "Good Looks May Help: Effects of Helper's Physical Attractiveness and Sex of Helper on Males' and Females' Help-seeking Behavior," *Journal of Personality and Social Psychology* 42 (1982): 90–99.

Pantene ad. Nancy Friday, *The Power of Beauty* (New York: Harper Collins, 1996), 78.

contrast effect. D.T. Kenrick and S.E. Gutierres, "Contrast Effects and Judgments of Physical Attractiveness: When Beauty Becomes a Social Problem," *Journal of Personality and Social Psychology* 38 (1980): 131–40.

newspaper columnist, unearned advantage. Elizabeth Nickson, "Ruminations on Age and Beauty," *Globe and Mail*, 26 May 1999.

Joan Collins. A. Dillon-Malone, ed., *Women on Women and on Age, Beauty, Love, Men, Marriage...* (London: MacMillan, 1995), 85.

beautiful women not promoted. T.F. Cash and R.N. Kilcullen, "The Eye of the Beholder: Susceptibility to Sexism and Beautyism in the Evaluation of Managerial Applicants," *Journal of Applied Social Psychology* 15 (1985): 591–605.

handsome disadvantages. U. Mueller and A. Mazur. "Facial Dominance of West Point Cadets as a Predictor of Later Military Rank," *Social Forces* 74 (1996): 823–50.

Candace Bushnell. Lisa Gabriele, "Venality in the City," *National Post*, 16 August 2003.

Gloria Steinem. Friday, *The Power of Beauty*, 333–34.

Charlize Theron. Holly Millea, "If Looks Could Kill," *Elle Magazine*, June 2003.

Mena Suvari. Noreen Flanagan, "Lucky Star," *Elle Canada,* March 2003, 64.

Jon Bon Jovi. "Rock of Ages," *Elle Canada*, June 2003, 58.

CHAPTER 8: COMPETITION 24/7

rating guys. *CosmoGirl*, Dec. 2003/Jan. 2004; *Elle Girl*, Nov./Dec. 2003.

judgment of Paris. www.calliope.free-online.co.uk/helen/paris9.htm

P.T. Barnum, history of Miss America pageant. Public Broadcasting Service, www.pbs.org/wgbh/amex/missamerica/peopleevents/e_origins.html; Candace Savage, *Beauty Queens: A Playful History* (Vancouver: Greystone Books, Douglas and McIntyre, 1998), 15–55.

1968 protest. Susan J. Douglas, *Where the Girls Are: Growing up Female with the Mass Media* (New York: Times Books, 1994), 139–41.

controversies. "Nigeria buries its dead," BBC News, 25 November 2002, http://news.bbc.co.uk/1/hi/world/africa/2510743.stm; Emma Daily, "Reporter's Bribe Exposes Spanish Beauty Contests' Ugly Face," *New York Times*, 11 April 2002.

brown paper bag contest. Elizabeth Haiken, *Venus Envy: A History of Cosmetic Surgery* (Baltimore: Johns Hopkins University Press, 1997), 12.

Miss America 2003. Nikitta A. Foston, "Miss America Takes a Stand on Abstinence and Bullying," *Ebony*, March 2003.

media effects. Heidi D. Posavac, "Exposure to Media Images of Female Attractiveness and Concern with Body Weight among Young Women," *Sex Roles: A Journal of Research*, February 1998 (all academic articles are available at www.findarticles.com); Brenda L. Spitzer, "Gender Differences in Population Versus Media Body Sizes: A Comparison over Four Decades," *Sex Roles: A Journal of Research*, April 1999; Michael Levine, "Why I Hate Beauty," *Psychology Today*, July 2001; Martha M. Lauzon, "You Look Mahvelous: An Examination of Gender and Appearance Comments in the 1999–2000 Prime-time Season," *Sex Roles: A Journal of Research*, June 2002; Gordon B. Forbes, "Body Dissatisfaction in Women and Men: The Role of Gender-Typing and Self-Esteem," *Sex Roles: A Journal of Research*, April 2001; Kristen Harrison, "Television Viewers' Ideal Body Proportions: The Case of the Curvaciously Thin Woman," *Sex Roles: A Journal of Research*, March 2003; United Press International, "Fantasy Beauties Spoil Sex," *Vancouver Province*, 12 August 1996.

Debra Winger. Garth Pearce in Conversation with Debra Winger, "Why I Quit Hollywood," *London Guardian,* 1 August 2003.

Charlize Theron. Holly Millea, "If Looks Could Kill," *Elle Magazine*, June 2003.

impact of photography. Kathy Peiss, *Hope in a Jar: The Making of America's Beauty Culture* (New York: Metropolitan Books, Henry Holt, 1988), 45.

Christie Brinkley, Jamie Lee Curtis, Kate Winslet. "Re-modeling for Perfection," CBS News, 30 April 2003, www.cbsnews.com

Bobbi Brown. Bobbi Brown, Anne Marie Iverson, *Bobbi Brown Teenage Beauty: Everything You Need to Look Pretty, Natural, Sexy and Awesome* (New York: Harper Collins, 2000), 143.

reality check. "Mission Impossible," *People Magazine*, 3 June 1996; Norman Solomon, "From Barbie to Botox," www.tolerance.org, 10 May 2002.

CHAPTER 9: FLOGGING FANTASIES

prohibition against make-up. Candace Savage, *Beauty Queens: A Playful History* (Vancouver: Greystone Books, Douglas and McIntyre, 1998), 41.

money spent on beauty (versus education/social services). Nancy Etcoff, *Survival of the Prettiest: The Science of Beauty* (New York: Doubleday, 1999), 6, 82.

beauty by the numbers. "Pots of Promise," *Economist*, 22 May 2003; "Smooth Face, Big Botox," *Economist*, 16 February 2002; Cathy Newman, "The Enigma of Beauty," *National Geographic*, January 2000; Samantha Shatkzy, "New Cosmetic 'Fillers' Come from Cows and Cadavers," *Ottawa Citizen*, 10 August 2003, A6; Antonia Zerbisias, "Nip/Tuck lifts Bottom Line," *Toronto Star*, 9 September 2003; Ellyn Spragins, "Love and Money: A Makeover Can Be More Than Skin Deep," *New York Times*, 2 March 2003.

boys will be... Deirdre McMurdy, "Men Boost Beauty Business Boom," *Ottawa Citizen*, 4 September 2003.

deceptive advertising. Paula Begoun, *Blue Eyeshadow Should Absolutely Be Illegal: The Definitive Guide to Skin Care and Makeup Application* (Seattle: Beginning Press, 1994), 12–21; Gina Kolata, "A Question of Beauty: Is it Good for You?" *New York Times*, 13 June 1999.

is it the lingerie. Bernadette Morra, "La Senza's Better Way to Grab Our Attention," *Toronto Star*, 4 December 2003.

no ankle-biting, Helen Gurley Brown. Norman Solomon, "From Barbie to Botox," 10 May 2002, www.tolerance.org

credibility on a diet. James Cummings, "Putting the Squeeze on Diet Scams: Truth vs Fiction," *New York Times (Syndicate)*, 5 February 2003; David Stout, "U.S. Bans Dietary Supplement Linked to Number of Deaths," *Washington Post*, 30 December 2003; "Supplement Industry is Full of Quacks," *USA Today Magazine*, August 2003; Michele Meyer, "Top 7 Dieting Myths," *Better Homes and Gardens*, June 2001; Kaz Cooke, *Real Gorgeous: The Truth about Body and Beauty (*New York: W.W. Norton), 33–52.

unreality programming. Ruth Shalit, "Extreme Makeover: The Truth Behind the TV Show," *Elle*, January 2004; Nipped, Tucked and Talking," *People Magazine,* 1 September 2003, 106.

lights! cameras! clearasil! Aaron Sands, "High-Definition TV Exposes Hollywood's Ugly Truths," *Ottawa Citizen*, 30 May 2003.

unmasking the makeovers. Dina Sansing, "Great skin (as seen on TV)," *Seventeen,* October 2003, 142; Dorothy Schefer, *What Is Beauty: Nouvelles Definitions* (Paris: Editions Assouline, 1997), 58, 140; "Remodeling for Perfection," www.cbsnews.com, 30 April 2003; "Nipped, Tucked and Talking," *People Magazine,* 1 September 2003, 106.

ok, *don't* smile. Susan Bordo, "The Empire of Images," *Chronicle Review*, 19 December 2003.

Venezuelan beauty contestants. *Economist* 315: 7653 (5 May 1990): 100.

addicted to the knife. "The Real Story Behind Michael Jackson's Plastic Surgery," San Antonio Texas NBC affiliate News 4 WOAI, 17 February 2003; Dr. Kenneth Dickie, "Back for More Surgery?" *Nassau Guardian*, http://freeport.nassauguardian.net/ social_community/279228379355871.php

CHAPTER 10: A DAY IN THE LIFE

Julia Roberts, Susan Sarandon, Samantha Fox. A. Dillon-Malone, ed., *Women on Women and on Age, Beauty, Love, Men, Marriage...* (London: MacMillan, 1995), 84, 88.

Brooke Shields. Bobbi Brown, Anne Marie Iverson, *Bobbi Brown Teenage Beauty: Everything You Need to Look Pretty, Natural, Sexy and Awesome* (New York: Harper Collins, 2000), xi–xii.

Joel Schumacher. "Mission Impossible," *People Magazine*, 3 June 1996.

Julia Roberts. "Oprah Talks to Julia Roberts," *Oprah Magazine*, December 2003.

Morgan. Personal interview with author, 3 October 2003.

Agata. Interviewed by author for TV series, *DoubleTake*, broadcast on WTN, 1996.

Elia Saikaly. Personal interview with author, 15 October 2003.

dark side. Claire Cozens and Dan Milmo, "Campbell Privacy Case Thrown Out," *London Guardian*, 14 October 2002; Daniel Frankel, "Kate Moss, Drunken Catwalker," E! www.eonline.com, 17 February 1999; "Vanished: Shooting Star—The Life Story of Former Model Gia Carangi," NBC News (http://abcnews.go.com/onair/ABCNEWSSpecials/gia010423_feature.html).

Halle Berry. Kevin Sessums, "The 9 Lives of Halle Berry," *Elle Magazine*, October 2003.

introducing the make-*under*. Erica Goode, "Life's Wrinkles, Some of Them Ugly, Afflict the Beautiful, Too," *New York Times*, 13 June 1999.

Nikki Reed. Samantha Critchell, "Nikki Reed: Extraordinary and Average at the Same Time," Associated Press, 28 August 2003 (www.capitaljournal.com/stories/090203/tee_thirteen.shtml).

Justin Timberlake. Nicholas Jennings, "Justin Time," *Inside Entertainment*, summer 2003.

CHAPTER 11: BEYOND IMAGE

discrepancy theory. Nicholas Lezard, "You Really Can't Take it With You," *Guardian Weekly*, 30 October 2003, 19.

personality research. Clyde Haberman, "The Essence of Beauty? Ooh La Loren," *New York Times*, 9 May 2001; "A Reason To Smile," *Psychology Today*, March 1999; Nicole Bode, "Put on a Happy Face," *Psychology Today*, January 2001.

James Partridge. Elizabeth Austin, "Marks of Mystery," *Psychology Today*, July 1999.

voice research, supermodels. Nancy Etcoff. *Survival of the Prettiest: The Science of Beauty* (NewYork: Doubleday, 1999), 237.

ACKNOWLEDGMENTS

THE AUTHOR WOULD LIKE TO THANK:

Morgan Reynolds, Elia Saikaly, Rosanna Majeed, Val Brousseau, Amanda Parriag, and Agata Kesik for overcoming the embarrassment implicit in the act of giving an interview about growing up beautiful;

Tom, Lev, Brook, Nathan, and especially Tim for giving up a Sunday afternoon to talk about beauty;

Megan and Elizabeth for sharing their personal experiences and perceptions;

Renate Mohr for being a wonderfully supportive and perceptive first reader;

Melanie Cishecki and Deborah Barretto for bringing their MediaWatchers' eyes to the manuscript on a tight deadline;

Peter Fowler for undertaking an unusual shoot and delivering some wonderful photos;

Sandra Booth for her creative and enthusiastic photo research;

Pam Robertson, whose unerring instincts provided crucial direction for the book's shape and tone;

My parents, Norma and West, for raising me to care more about substance than image; and most of all,

David Mitchell, whose expressed love and appreciation provide invaluable support for my ongoing efforts to practice what I preach.

Thanks also to the following individuals for their participation in and/or permission for the inclusion of photographs: Chou So, Stephanie Boucher of Hair Extreme; Shawn Carrier of Inkspot Tattoo; Elena Falvo of Mostly Makeup; Heather Lee Davies, Anna Harris and Margarita Nevelson, Tyler Elkington, Sharleen Hamm, June Callwood, Nate Redmon, David Wichman, Lisa Cheung, Daniel Choi, Dan Wong, Jo-Ann Panneton, Ash Katey, Gino Burich, Kathryn Sigstad, and Jesse Curtis.

PHOTO CREDITS

INDEX